STUNNING CRYSTAL & GLASS
THE WATERCOLORIST'S GUIDE TO CAPTURING THE SPLENDOR OF LIGHT

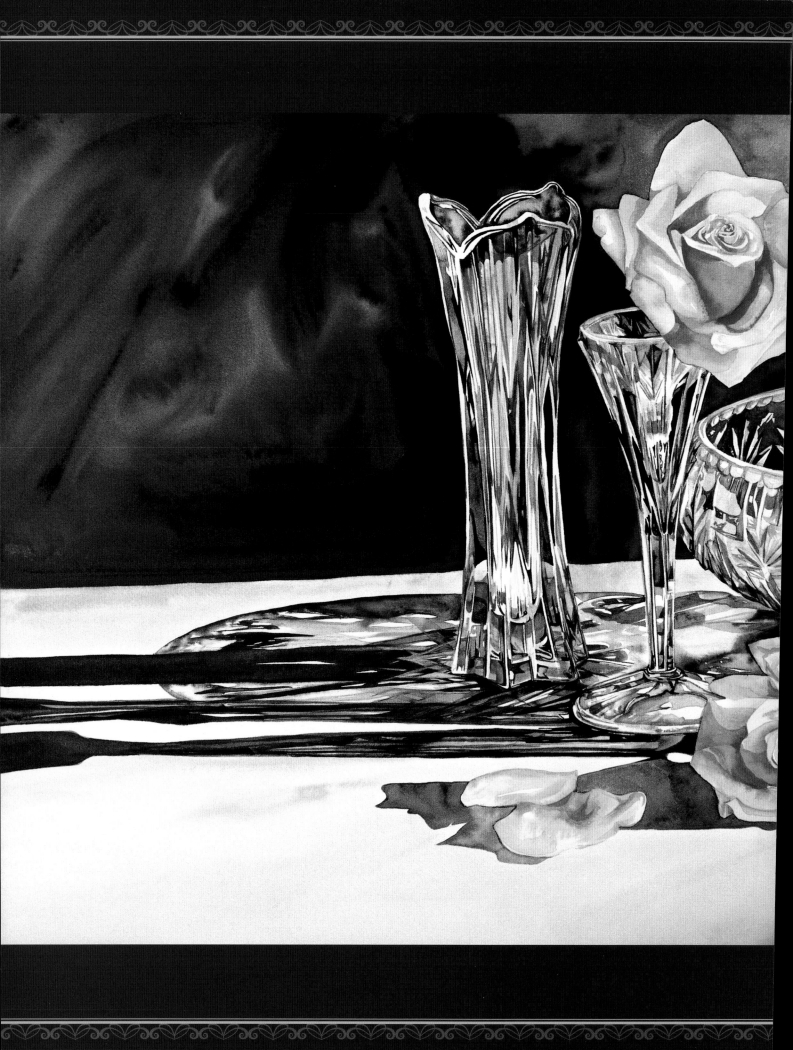

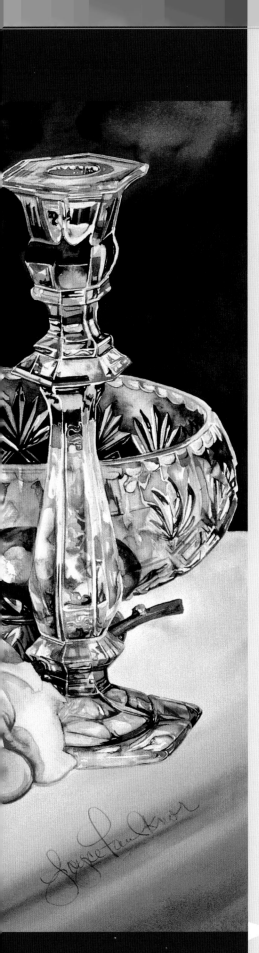

STUNNING CRYSTAL & GLASS

THE WATERCOLORIST'S GUIDE TO CAPTURING THE SPLENDOR OF LIGHT

JOYCE ROLETTO FAULKNOR

NORTH LIGHT BOOKS
CINCINNATI, OHIO
www.artistsnetwork.com

ART ON PAGES 2-3

CRYSTAL & ROSES
22" x 30" (51cm x 76cm)
Watercolor on 140-lb. (300gsm) cold-pressed paper

Stunning Crystal & Glass: The Watercolorist's Guide to Capturing the Splendor of Light. Copyright © 2006 by Joyce Roletto Faulknor. Manufactured in China. All rights reserved. No part of this book may be reproduced in any form or by any electronic or mechanical means including information storage and retrieval systems without permission in writing from the publisher, except by a reviewer who may quote brief passages in a review. Published by North Light Books, an imprint of F+W Publications, Inc., 4700 East Galbraith Road, Cincinnati, Ohio, 45236. (800) 289-0963. First Edition.

Other fine North Light Books are available from your local bookstore, art supply store or direct from the publisher.

10 09 08 07 06 5 4 3 2 1

DISTRIBUTED IN CANADA BY FRASER DIRECT
100 Armstrong Avenue
Georgetown, ON, Canada L7G 5S4
Tel: (905) 877-4411

DISTRIBUTED IN THE U.K. AND EUROPE BY DAVID & CHARLES
Brunel House, Newton Abbot, Devon, TQ12 4PU, England
Tel: (+44) 1626 323200, Fax: (+44) 1626 323319
Email: mail@davidandcharles.co.uk

DISTRIBUTED IN AUSTRALIA BY CAPRICORN LINK
P.O. Box 704, S. Windsor NSW, 2756 Australia
Tel: (02) 4577-3555

Library of Congress Cataloging in Publication Data
Faulknor, Joyce Roletto.
 Stunning crystal & glass : the watercolorist's guide to capturing the splendor of light / Joyce Roletto Faulknor.
 p. cm.
 Includes index.
 ISBN-13: 978-1-58180-753-0 (alk. paper)
 ISBN-10: 1-58180-753-8 (alk. paper)
1. Glass in art. 2. Shades and shadows in art. 3. Watercolor painting--Technique.
I. Title: Watercolorist's guide to capturing the splendor of light. II. Title: Stunning crystal and glass. III. Title.
 ND2365.F38 2006
 751.42'2435--dc22 2006002783

Edited by Vanessa Lyman and Mona Michael
Designed by Wendy Dunning
Production art by Lisa Holstein
Production coordinated by Jennifer Wagner

ABOUT THE AUTHOR

Joyce Roletto Faulknor was born and raised in San Mateo, California. Because she came from a very creative family, art was a large part of her life. She knew at a very young age that she would grow up to be a part of the art world. Studying art was second nature; deciding on a medium, however, was difficult. While studying to become an illustrator at the Academy of Art in San Francisco, she discovered watercolors and knew she'd found the medium that was exactly perfect for her. As a result, she changed her focus from illustration to watercolor. In 1990, Joyce found the perfect combination of writing and teaching as she owned and operated Emerald Lake Art Academy, teaching children and adults to draw and paint. Joyce Faulknor considers herself a self-taught artist, having learned that breaking the rules of watercolor was a way of standing out.

PHOTO: PHOTOWALL DESIGN

METRIC CONVERSION CHART		
To convert	**to**	**multiply by**
Inches	Centimeters	2.54
Centimeters	Inches	0.4
Feet	Centimeters	30.5
Centimeters	Feet	0.03
Yards	Meters	0.9
Meters	Yards	1.1

ACKNOWLEDGMENTS

Thanks to my mom and dad for raising three daughters and teaching us to go for our passions in our life and to never settle; to my sister Jan, the marine biologist who took the time to understand my artist's world; and to my sister Denice, your talent encouraged me to work hard.

To Mary and Forrest Faulknor for your support and encouragement.

To my warm and loving friends, Joanie and Ian Crombie, who believed in me, and listened to me go on and on endlessly about my book.

To my favorite watercolor class, for giving me the time I needed to work on this book.

To Evelyn Sleppy and Dolly Steyer, for trying out the demonstrations.

To the Redwood City Art Center, Barbara Britschgi and my fellow artists at the art center.

To Guy Magallanes, for your technical support. You are the master of watercolor.

To my studio mate Marie Souderlund, who brought warmth, laughter and a special talent to our studio.

To Janet Wilkerson for teaching me to teach. Thank you for seeing a diamond in the rough.

To Arleta Pech for encouraging me to move forward and write this book.

To Maggie Paaluo of Maggie Art and Drafting Supplies, thank you for the many years of stocking all my favorite products. You're the best.

To Valega's Photo Lab for your quick service and encouragement with my photography.

To the North Light editors: Rachel Wolf, for asking me to write this book; Jamie Markle, for keeping me encouraged; Vanessa Lyman for your wisdom and kindness; and Mona Michael, for bringing me to the finish line. Thank you for bringing me into the North Light family.

DEDICATION

To the three most important people in my life: My best friend and loving husband, Michael, you gave me the strength and encouragement for the past twenty-nine years. Without you I would not have been here to accomplish so much. And to my two wonderful, beautiful kids Graham and Katie Faulknor. Thank you all for being so patient and understanding of the time that I had to spend in order to work, learn and hone my craft. Your heartfelt and ongoing encouragement and support keep me moving forward and believing in myself. Love you always.

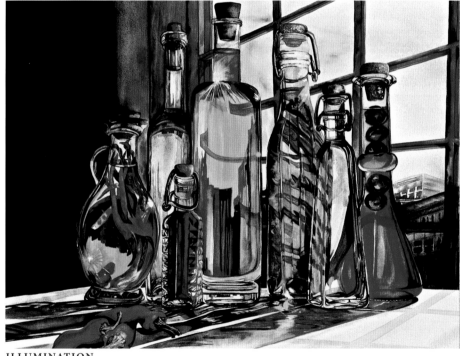

ILLUMINATION
22" x 30" (56cm x 76cm)
140-lb. (300gsm) cold-pressed paper

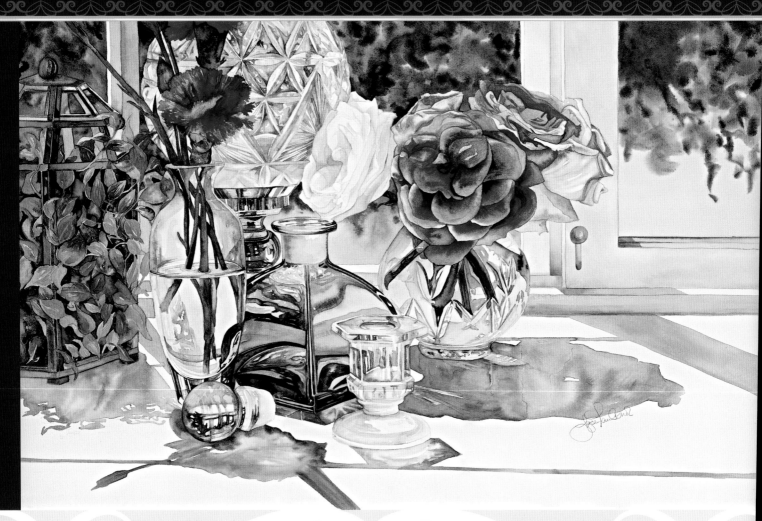

TABLE OF CONTENTS

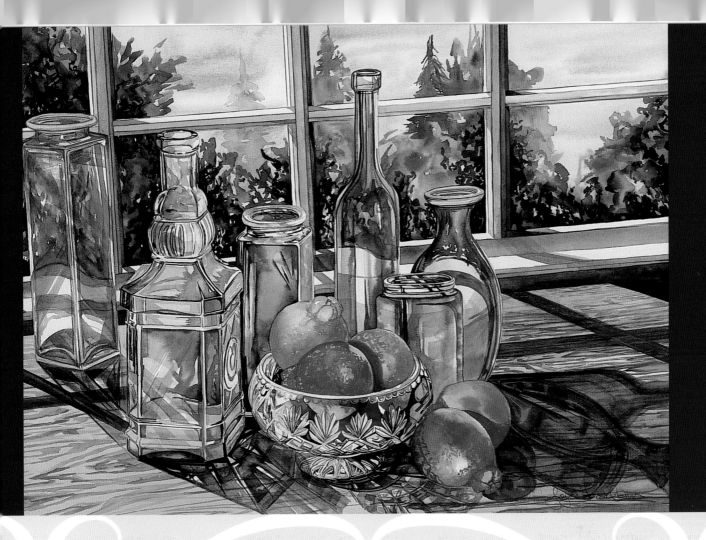

INTRODUCTION

Learning to paint glass objects was a journey for me. I searched for the answers through books and elaborate still life setup experiments.

I remember my first still life. I thought, *The more the better*, so I set up seven glass vases on a glass tabletop and poured water on the tabletop to give it a glossier surface. I shot off a roll of film and thought, *Boy, this is great. I'm going to have the greatest reference photos to work from.*

I got the photographs back and began to draw this complex monster. I didn't have a clue as to how to paint the subject. But I thought to myself, *I have some watercolor experience; I will learn as I go.* Well, sixteen months later I eventually got the hang of painting glass. Not with the original seven-piece still life, but with one simple, clear vase and a flower with a simple shadow.

That's how I learned that less is better for experimentation at the beginning. And that is how I will walk you through the process of learning to paint glass—by starting with one simple piece. Then you will work your way into the more complex pieces. And all the while you'll be learning to look at glass with a new appreciation.

Often my students will return to class after having worked on a painting saying, "I cannot stop looking at water glasses, salt and pepper shakers, and the reflections on windows." So be prepared. You will never look at glass, cut crystal or reflective surfaces the same way again. You will begin to see with a painter's vision.

You will see the fabulous distorted patterns and the contrasting values. You will begin to notice that the darkest dark and the lightest light are generally next to each other. You will learn that even the simplest piece of glass contains extraordinary shapes within shapes. You will appreciate the soft and hard edges, perfect for watercolor. And just when you think you have a great variety of shapes and values, you will tilt your head and discover the prism—a beautiful rainbow shining through. Glass is so giving that you can paint what you see or just go wild with shape and color.

You will learn my dark-to-light approach, laying in the darkest shapes and allowing the darkest values to create the foundation for the painting. You'll then be able to paint and glaze from there until your paintings are complete. I hope that you will find the joy and excitement of painting glass as you work along with the easy-to-follow, yet wonderfully challenging demonstrations to come.

GERBERA I
36" x 24" (91cm x 61cm)
140-lb (300gsm) cold-pressed paper

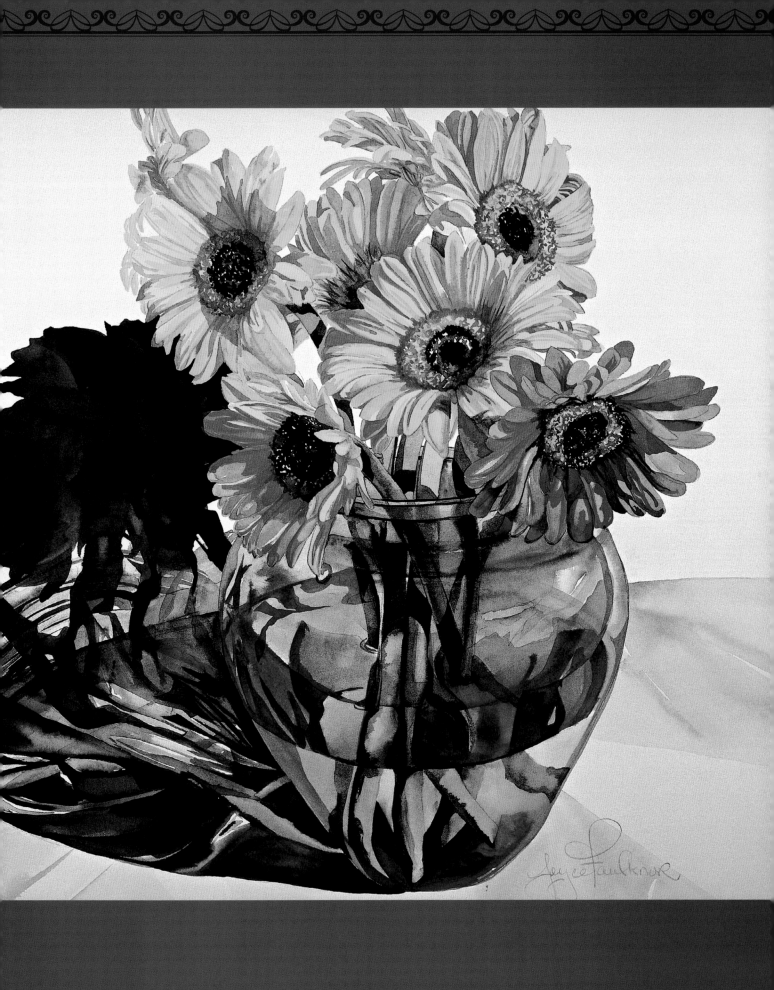

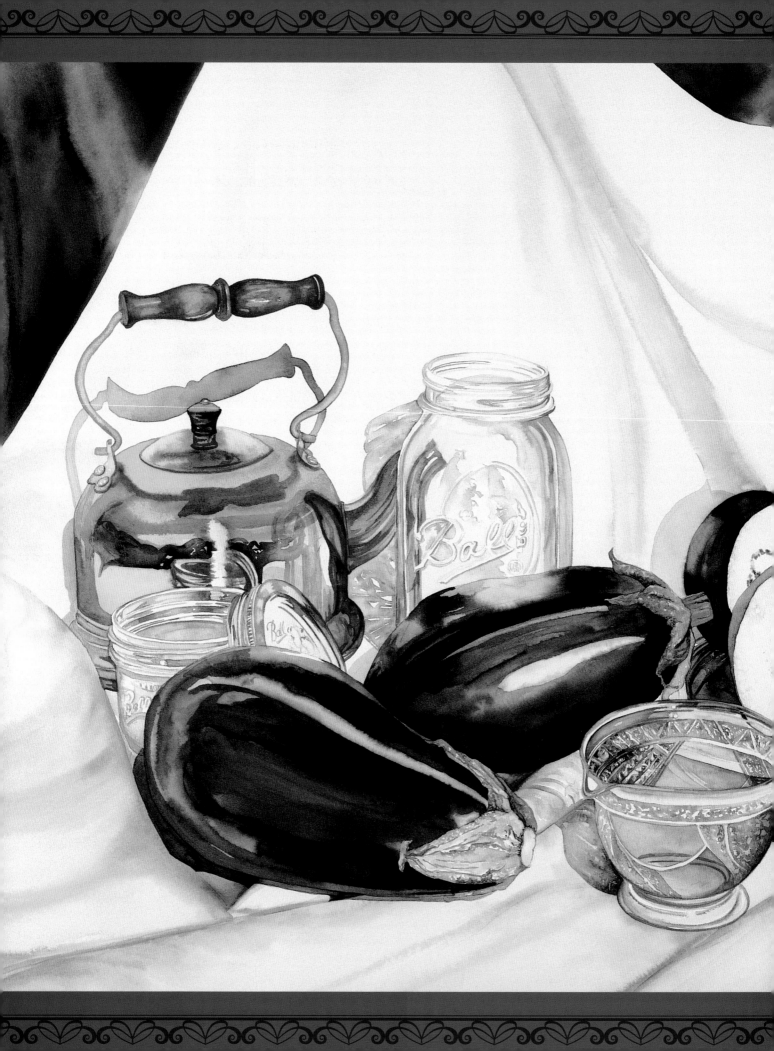

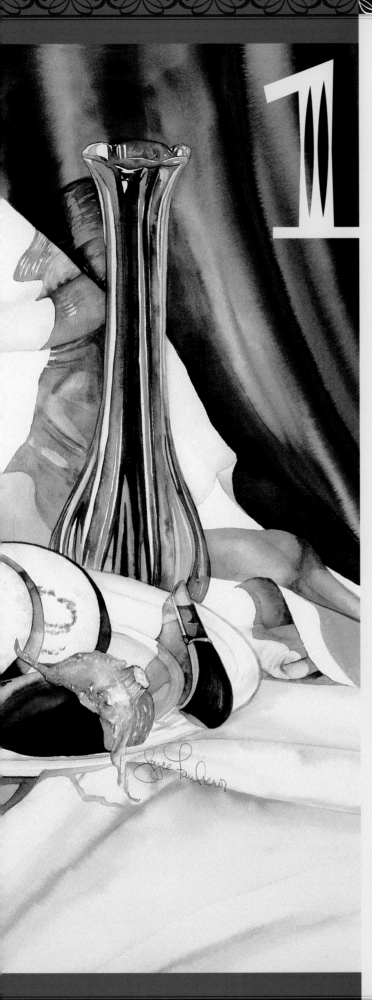

GETTING STARTED

Painting is like making pancakes. Pretend that you have never seen a batch of pancakes made from beginning to end. If you were to see the batter, all lumpy and pasty-looking, you would never dream that the finished product would be a golden stack of delicious, round cakes with butter and syrup topping it off. Your painting is the same. Many of my students get into the middle of a painting and find that they want to quit before seeing the beautiful results. You may find yourself in the middle of painting and want to stop; do not. Keep going; the end results will not only amaze you, but they will also build your confidence for the next painting and all the rest after that. Learning to trust the process is perhaps the biggest lesson an artist can learn.

Once you have made the trip to the art store and purchased your brushes, watercolor paints and paper, it is time to select your subject. This book is filled with fascinating objects to paint.

Now let's get started...

COOKING LESSON
24" x 36" (61cm × 91cm)
140-lb. (300gsm) cold-pressed paper

Studio Set-Up

The purpose of a studio is to have somewhere to work that also allows space for your art supplies. Having space for your art supplies is most important. It doesn't matter if it is a large studio space or a small corner in your home. If you keep your supplies out and set up, you will always have a moment to go paint.

My studio setup is compact but functional. Key items include:

- An L-shape and a rolling chair to allow easy access to both computer and painting surface.

- A drafting table instead of an easel since it can be either tilted or flat. I like the flat surface so I can spin the piece in order to reach and paint in comfort. I tilt the table for larger pieces.

- Large paper drawers to store water-color paper, class lessons and giclée prints, and compact drawers to keep supplies.

- A large closet to store glassware and photography equipment.

Comfortable chair

Paper drawers, under the computer table (behind the chair)

Computer makes it easy to store and find reference photos.

Lamp with warm and cool bulbs for a natural light

Adjustable table so you can paint flat or at a tilt

Setting Up Your Space
Make sure you are comfortable in your space and that you have room to leave your supplies out and ready for use. Make it easy for yourself to sit down and paint.

MY STUDIO

My studio is in an art center with twenty-eight other artists. I share my space with my friend and colleague, Marie Souderlund. It is 50' x 25' (15m x 8m). We get foot traffic daily and also rent out the walls and window space to other artists to help supplement our income and pay the rent.

Painting in this type of space can be a challenge with the public strolling through, but the pluses outweigh anything negative. The public gets a chance to see our showroom and they also get to see our work in progress. Marie and I will always stop and take the time to explain what our medium is and how we go about our process. I have had a studio at home where the quiet and solitude drove me crazy. I love the interaction with all the other artists here at the Redwood City Art Center. We inspire each other along with trading secrets.

Materials

While I understand the balance that must be struck between supplies and your budget, you should still buy the best supplies on the market. You don't want to practice with cheap paper and paint, because then you will never know whether it is you or the supplies that are not working. Spend a little more for a few quality supplies now, then add additional items as you can afford them. Buying supplies is an investment in yourself, the artist. You are worth it.

Paper ◆ For painting crystal you need a surface that has tooth but is still smooth enough to allow detail and straight lines. I use Arches 140-lb. (300gsm) cold-pressed paper. It is a good, reasonably priced, high-quality paper that fills all the requirements for painting glass.

Paint ◆ Artists all have their favorite brands of paint. Experiment to see what works best for you; my choice is Winsor Newton professional grade. It is consistent, predictable and available at most art stores. The professional grade is more finely ground than student grades and the colors are richer and more intense. It costs a little more, but if you purchase the 14-ml. tube, you will save both money and trips to the art store. The professional grade goes farther, too, because of the intense color.

Brushes ◆ Finding your favorite brushes is largely a matter of trial and error. Until you complete your search, it's best to buy directly from your local art store rather than from a catalog. This way you can feel and test the brush. The store should have a jar of water next to the brush section (if not, ask for one). Dip the brush into the

water and give it a good flick. Round tips should come back with a good point. Flats should not split, but should bounce back with a firmness. I have painted with many types of brushes over the years. My favorite are the Robert Simmons White Sables.

Palette ◆ My favorite palette is a white butcher pan. It doesn't yellow or stain and it is bright white, allowing you to truly see hue and value. It also keeps you replenishing the paints so that they are fresh, and you always keep it clean. Your paintings are only as good as the pure color in your palette.

Paper towels ◆ You need these to keep your palette and work area clean and to blot moisture from your brush. I like white Viva paper towels with no quilting. They seem to absorb just

My Favorite Paints and Brushes
Dependable paints and brushes are among the necessities for painting glass. My favorite brush set is Robert Simmons and includes: no. 6 round, ¼-inch (6mm) flat, ½-inch (12mm) one-stroke, ¾-inch (19mm) one-stroke, 1-inch (25mm) one-stroke (all cost under $20).

The white butcher pan makes a perfect palette.

the right amount. If the towel is too absorbent, it will dry out the brush too quickly. If it's not absorbent enough, the brush will be too wet for painting.

Plastic jar ◆ The jar needs a large opening and should hold at least four cups of water. Keeping your water clean is key for not muddying your pigment, and a large jar keeps the water cleaner for a longer period of time than a small one does. Fill your container all the way to the rim to keep from having to reach too far.

Setting Up a Still Life

Still lifes work best when you choose objects that mean something to you. Work with those objects to create a *focal point* (center of interest) and to direct attention to that focal point. Look for contrasting shapes, sizes and textures. Allow objects to overlap each other to create depth. Experiment with color and light.

Generally, the distorted shapes and the refracting light will be the focal point of a still life with glass. The focal point could also be the most active area or the brightest of the objects or the piece that inspired you to create the still life. The main rule for developing a focal point is to avoid placing it dead center. This will create a monotonous composition.

When arranging objects, play with primary colors at first and work with your lights to create interesting shadows.

Do not be hesitant about using one or two rolls of film for one still life. Shoot from all directions, as the camera may pick up elements that you are not seeing at that moment. Leave the still life set up until your film is developed. If you have the space, you can leave it set up for the duration of your painting.

Begin With a Simple Setup
Try a simple vase and an elongated shadow. Use a spotlight with a 500-watt bulb and play with the light to create a fascinating shadow. Setting your still life on white foamcore board will create a beautiful shadow. The slick surface allows the light to bounce and enhance the still life.

Beginning a More Complex Setup
Using the same lighting, this time begin with a drapery and add a few folds. Use the folds to direct the viewer's eye to the focal point. Or add a piece of glass that will reflect a bright shadow onto the fold to help create a focal point.

Add Interest
A bit of lace will break up the solid blues of the background.

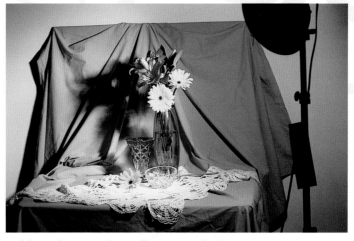

Add the Tallest Piece First

Placing the tallest piece first allows you more freedom to decide whether you want it off to the right or left. Don't put it right in the middle, though. Add just a few flowers (you can always add more). Fewer is better; adding is easier than pulling the flowers back out of the arrangement. This will prevent water spilling and vases tipping.

Add Medium and Small Pieces of Glass

The cut crystal will add some nice contrasts in shape, size and texture. The objects overlap and create variation of negative spaces within. As you are adding the shapes, think of them not as objects but as different values to create a checkerboard effect of lights against darks.

A Finished Setup

Once you've set up your still life just the way you want it, you can crop your reference photo to get the exact composition you want.

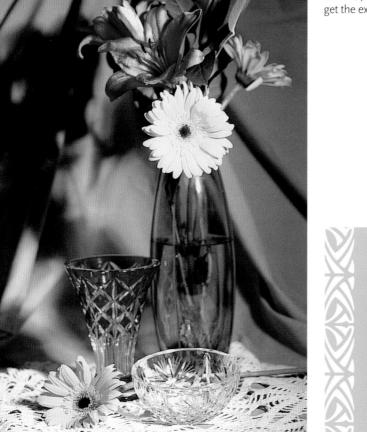

PHOTOGRAPHY TIPS

Using a 35mm camera and a macro lens gives you the best of indoor and outdoor photography. The macro lens will get all the detail of the glass and allow you to shoot close up. Fuji 400 is a great film that provides a clean, clear and correct color adjustment. When shooting a roll of film, don't hesitate to shoot off a whole roll of 24 or 36. Find a photo lab you like and take your film there consistently to create a relationship with that store. They will get to know you and your work and not hesitate to correct your color for your prints.

Working From Reference Photos

Reference photos are the way to go when painting cut crystal and glass. The photograph will capture that moment in time when the light is hitting the glass and creating a prism effect. Painting a still life with cut crystal and glass without the photo may become confusing because what you see will change any time you look at the still life from a different vantage point or with slightly different light.

Have your film developed at least at 5" × 7" (13cm × 18cm); it makes a world of difference from the 4" × 6" (10cm × 15cm) size. I generally go a step further and have my photos enlarged to 8" × 10" (20cm × 25cm) to give me even more information.

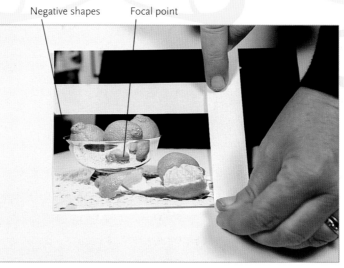

Negative shapes Focal point

Crop Your Photos to Arrange Composition
Once your film is developed, you may find one photograph more interesting than another, but the composition may need a little more work. Cropping the photo is an ideal solution to this problem. In this photo I completely cropped out the candlestick and decided to use the shapes reflecting onto the sterling silver bowl as the focal point. This will also allow you to add interesting negative shapes. You can crop using a scanner or with white tape on the photograph.

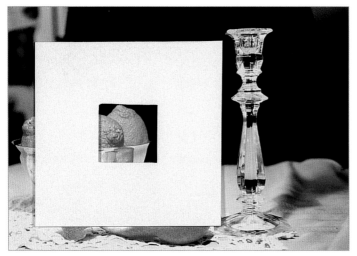

Paint One Section at a Time
Cut out a square shape within a piece of paper, place it on the reference photo and move it as you need to. Once you have begun, you may want to use this method to keep your eye on the area where you are painting.

Zoom In on Shapes
Investigate the interesting shapes that appear within the reflective objects. It's much easier to paint certain shapes once you have seen them enlarged. Zoom in on these areas with either a scanner or color copier.

EXERCISE
Transferring a Drawing

While teaching watercolor, I have discovered that most students want to jump into the medium of watercolor right away, rather than begin with a lot of drawing basics. There are drawing courses for that.

To get to the painting as soon as possible, I'll show you how to transfer a drawing. Transferring is a great way of saving time and getting the subject onto the paper correctly.

First, have an 8" × 10" (20cm × 25cm) color enlargement made of your photo reference. This will keep the color accurate, while still being large enough to give you good shape information.

Then, to create the transfer drawing, you can enlarge the photo still more on a copy machine. Some copy machines will only enlarge up to 11" × 17"(28cm × 43cm). If you want to work bigger than that, you will have to enlarge separate pieces of the photo and tape them together like a puzzle.

SUPPLIES

140-lb. (300gsm) cold-pressed paper
Artists tape
HB pencil
Transfer Paper

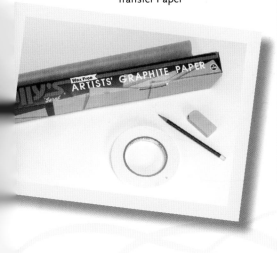

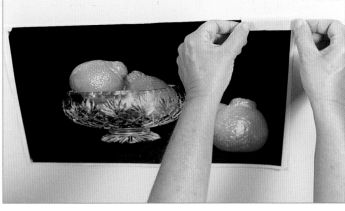

1 SECURE THE COLOR COPY
Tape your transfer color copy directly to the watercolor paper. Place one piece of tape at each end of the color copy. This will keep it in place as you're transferring, and you can check on the drawing as you work.

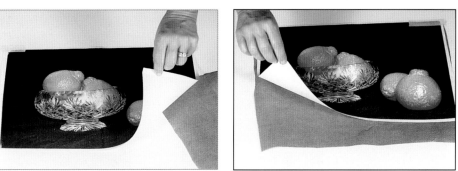

2 PLACE THE TRANSFER PAPER
Slide the transfer paper under the color copy. Be sure the dark side (the graphite side) is facing down.

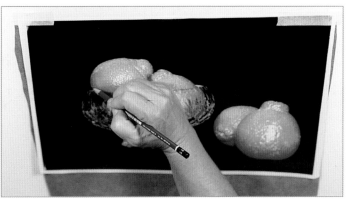

3 MAKE THE DRAWING
Draw directly onto the color copy with a sharp pencil. Lift the paper often to see if you are applying enough pressure to transfer the pencil marks onto the watercolor paper.

EXERCISE
Paper Preparation

It's important to work on a taut sheet of paper that you can easily maneuver while you paint. If you work on unstretched watercolor paper, eventually the paper will bend and even cause a hump in the middle. These ripples will cause the pigment to dry unevenly.

Preparing your surface properly allows the paint to dry evenly on the top and bottom. This prevents the pigment from embedding itself into the paper as well as keeping it from drying too light. I love working on this prepared surface.

SUPPLIES

140-lb. (300gsm) cold-pressed watercolor paper
Stretcher bars
Lightweight staple gun
Scissors/craft knife

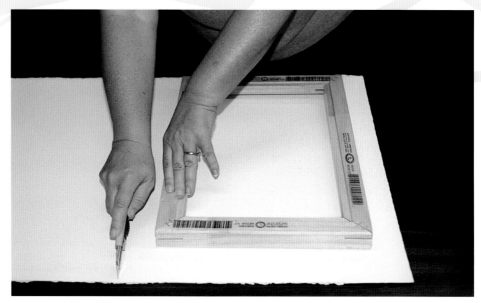

1 CUT THE PAPER
Cut the watercolor paper approximately four inches (10cm) wider and longer than the dimensions of the stretcher bars.

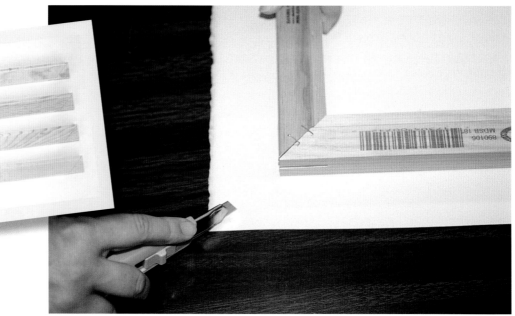

2 MATCH THE PAPER TO THE BARS
Cut slits from the corners of the paper to the corners of the stretcher bars.

3 WET THE PAPER

Hold the paper under a faucet just long enough to moisten the surface.

4 LINE UP THE PAPER WITH THE STRETCHER BARS

Lay the paper face down. Be sure the correct side is facing down: You should be able to read the watermark or the manufacturer's label, with the front (smoother side) facing down. Position the stretcher bars over it and apply one staple along each side.

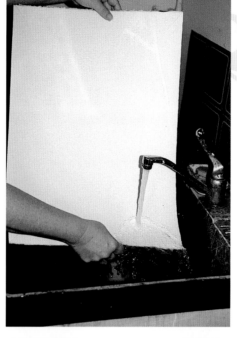

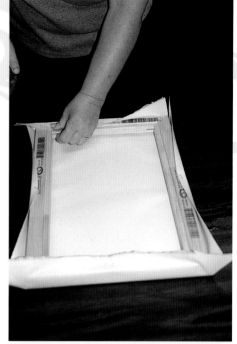

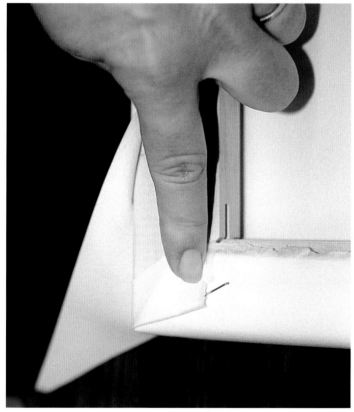

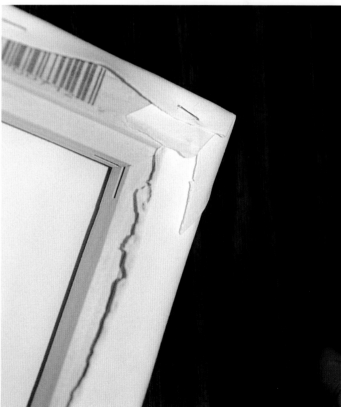

5 ATTACH THE PAPER TO THE STRETCHER BARS

After you staple along the four sides of the paper, fold and staple the slits at the corners. Allow the paper to dry thoroughly so it's as tight as a drum.

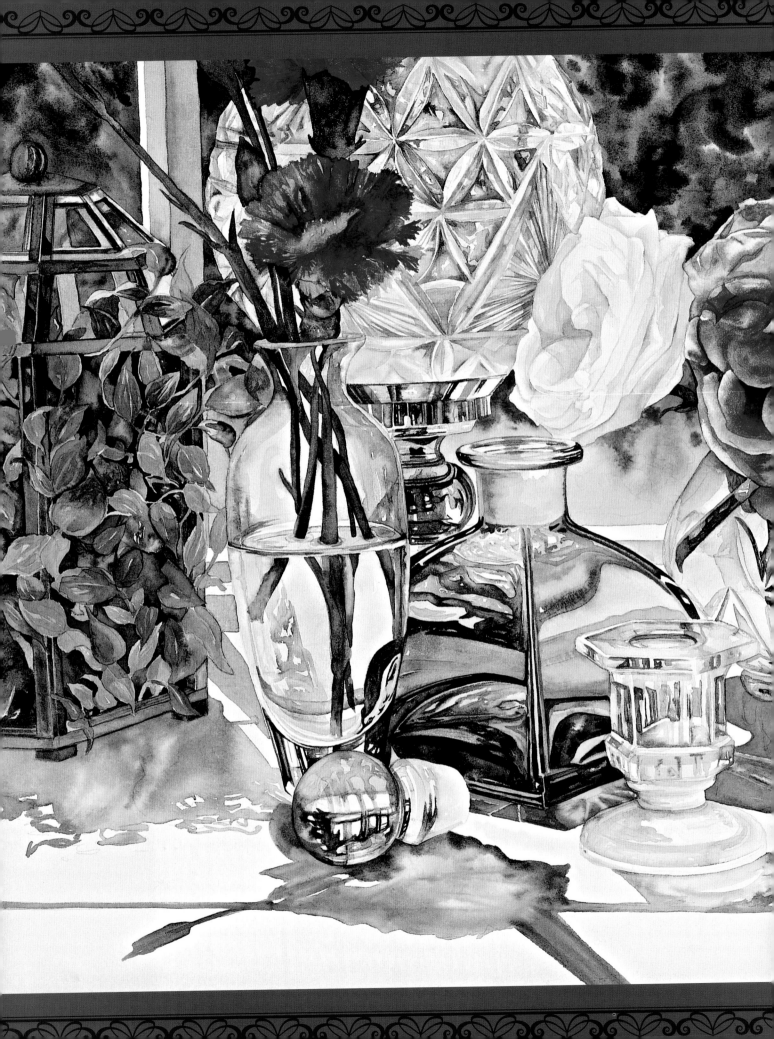

2 COLOR & LIGHT

Glass is a neverending source of information for the artist. Understanding the light and color of glass will help prepare you for success in all your watercolor paintings. Value contrasts, the lights and darks in your painting, create light. Light refracting through a prism creates a rainbow of color.

Understanding the prism effect is a wonderful jump start to understanding glass. This effect is something that we all have seen. It is light that hits the glass and then splinters into a colorful rainbow. Once you are able to understand when and where this effect happens in glass and how it affects cut crystal, you will have the creative license to play up the colors and make them your own. Clear glass, colored glass, reflective surfaces and cut crystal will always have high contrasts of values. Once you have detected this, the rest is easy.

CRYSTAL MAGIC
18" × 34" (46cm × 86cm)
140-lb (300gsm) cold-pressed paper

Shadows and Light

When light hits opaque objects, the result is almost standard: You will find the core and cast shadows along with reflected light. Shadows that are created with glass are more unpredictable.

Shadows are just as important as the subject. They dictate whether or not the finished piece is anchored and looks three-dimensional. Most of my students discover shadows early on and how fun they can be to paint.

There are several elements of shadow to look for as you paint. These elements all behave differently depending on what type of glass you're dealing with.

- **Core shadow,** the darkest dark of any object is where the shadow reflects back onto the object and helps reveal its three-dimensional shape.

- **Cast shadow** is the shadow that is reflected onto the surface. It is on the opposite side of the object from where the light or sunlight hits. The object blocks the sunlight, which creates a shadow. You can play up the colors within the shadow.

- **Highlight** is the lightest light on the object.

- **Reflected light** usually occurs on the outside edge of the core shadow. It's caused by light reflected from the ground or surrounding objects.

All shadows have color, whether it's color reflected from the object into the cast shadow or color reflected in the core shadow coming from the object itself.

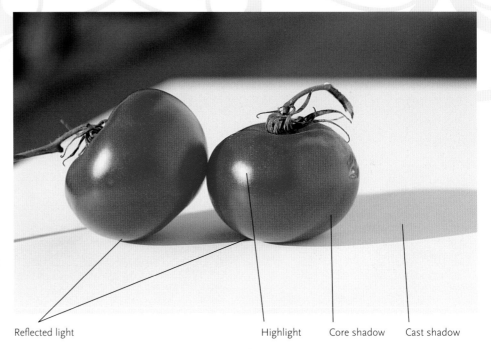

Reflected light Highlight Core shadow Cast shadow

Shadows From a Solid Object
The cast shadow from the first tomato carries reflected red from the tomato. When setting up a still life, look for these reflected colors so you can really play up the effects in your painting.

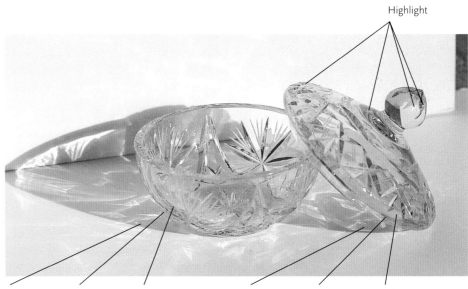

Highlight

Cast shadow Core shadow Reflected light Cast shadow Core shadow Reflected light

Shadows From Cut Crystal Glass
The splintered highlights of sunlight that run through the shadow occur when sunlight hits the facets of the crystal, which in turn hit the background surface.

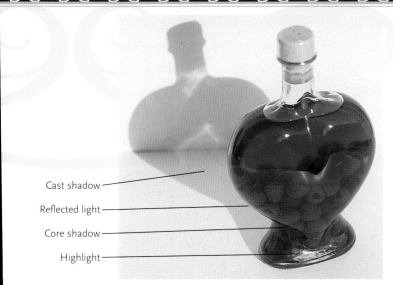

Cast shadow
Reflected light
Core shadow
Highlight

Color in Cut Crystal
The light hits the raspberry juice that is in this piece of glass and causes brilliant red to appear within the cast shadow.

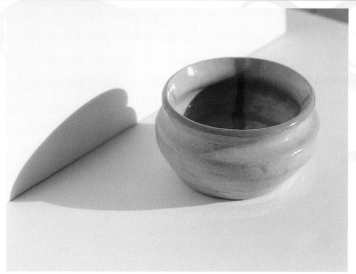

Ceramics
Ceramic produces the same sorts of cast and core shadows and reflective light that the tomatoes do.

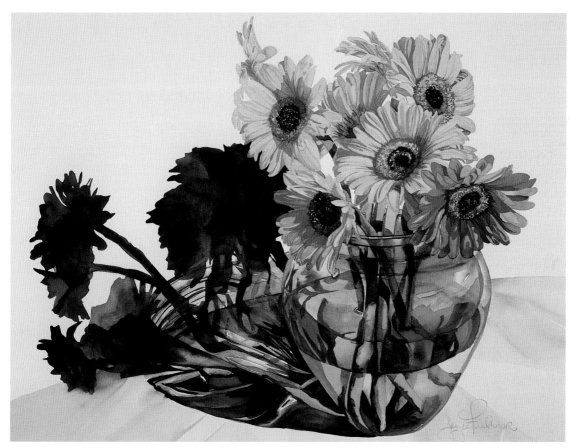

Begin With Simple, Bold Shadows
Set several of your favorite pieces outdoors in the morning sun on white foamcore board for an accurate look at the shadows. Start off with one piece, because you'll build your knowledge of the subject more thoroughly. If you pick one vase with a simple line and form, you can elongate the shadow, making the still life look dramatic.

GERBERA I
36" × 24" (91cm × 61cm)
140-lb. (300gsm) cold-pressed paper
Collection of Roger and Tammy Fearing

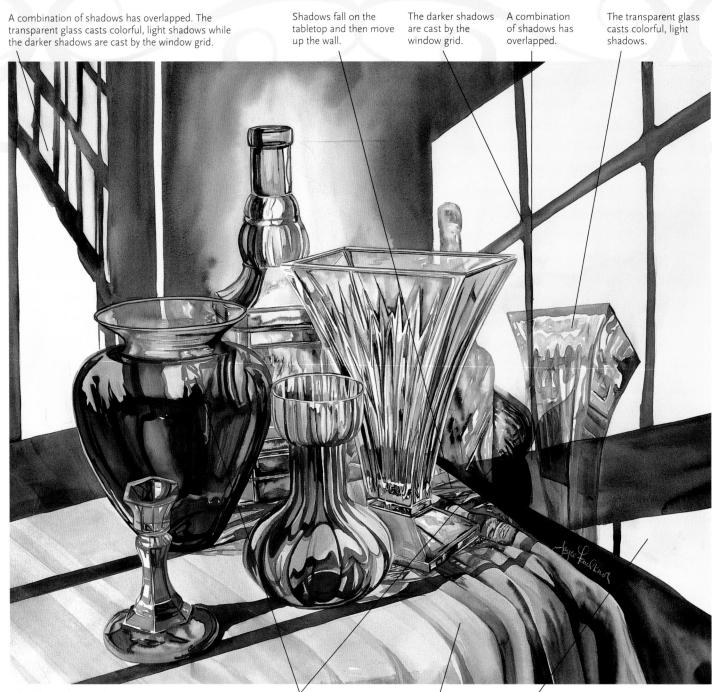

A combination of shadows has overlapped. The transparent glass casts colorful, light shadows while the darker shadows are cast by the window grid.

Shadows fall on the tabletop and then move up the wall.

The darker shadows are cast by the window grid.

A combination of shadows has overlapped.

The transparent glass casts colorful, light shadows.

Shadows in Action

Reflections is a great example of the variety of shadows that can be created through the transparency of glass.

REFLECTIONS

45" × 36" (114cm × 91cm)

140-lb. (300gsm) cold-pressed paper

The shadows cast by transparent subjects hold the color of the glass

The color of the tablecloth is blue, so I painted that first, then painted the shadows.

Though the local color of the wall is white, I glazed it with New Gamboge to bring in the warmth of the filtered sunlight.

ONE SHAPE AT A TIME

To avoid becoming overwhelmed by the complexity of the subject, remember that these are just shapes. Approach each still life one shape at a time, and before you know it, you'll have a completed painting. This still life is complex, but after you've experimented with one or two glass subjects, you'll be ready to move ahead with three to five.

THINGS TO REMEMBER ABOUT LIGHT

The play of light against glass is too complex to predict easily. The best way to deal with this is to let it happen. Don't try to predict where and what color these elements will be. Just paint what you see. There are, however, a few considerations that will help you as you begin painting still lifes involving glass.

- **Blocked light** happens when the light hits one side of an opaque object. This creates a solid shadow.

- **Transparency** does not necessarily mean clear. It just means you're dealing with something that you can see through; it can have color. The thinner the glass the more transparent it becomes.

- **Clear** glass can never be colorless. You will always be able to see the colors surrounding it.

- **Spliced light** occurs most often in direct light. The light appears to split, causing bright white splinters.

- **Distortion and Magnification** occur when you place an object behind a piece of glass. The shape of the glass and water added to the glass can exaggerate the effects. (See page 29.)

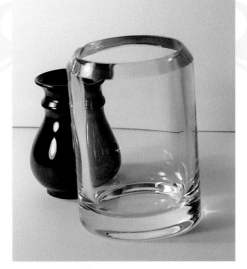

Opaque & Clear
Clear glass will always have some color. This is caused by the dense portions, the curves in the glass and the objects surrounding the glass. Even if it were sitting on a white tabletop with a white background there would be color in clear glass. Try it. You won't be able to make a perfectly clear piece of glass.

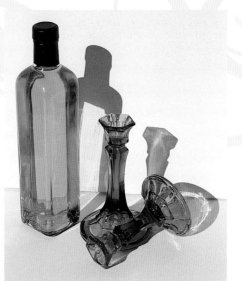

Blocked Light
The top of the transparent yellow bottle is opaque and throws a solid shadow. But when you paint that shadow, note that it is still not just one flat hue and value. If you cannot see the variations, make them up as you paint.

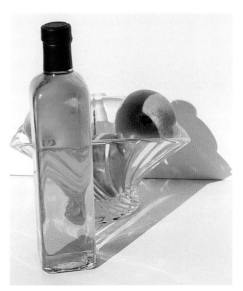

Magnification
A key element to painting glass realistically is to remember that glass magnifies anything you put behind or in it. It's also another great area in which you get to exaggerate what you see within your painting.

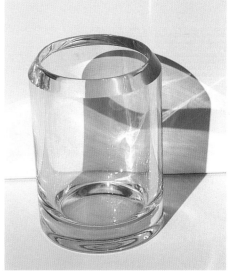

Spliced Light
Look for areas of white splintering. Exaggerate them for dramatic effect.

GLASS-FINDING CLUE

Do not think that the more expensive the piece is the prettier it will be. Some of the most beautiful pieces are the least expensive. Search your local antique store, secondhand store or discount department store.

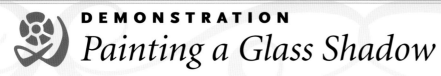

Painting a Glass Shadow

Unlike the shadows of opaque objects, which have a core and reflected light, glass and crystal cast shadows pass through the glass creating fabulous shapes within. The shapes of the shadow will change depending on the glass. Cut crystal has splintered shapes and prism effects. Clear glass also gives a beautiful cast shadow. Light hits the base of the vase, bouncing through the glass and hitting the tabletop, giving a burst of sunlight within the shadow. Colored glass, depending on the color and lighting, has cast shadows that give off dramatic color reflections. The transparency of watercolor is perfect for creating these enchanting images.

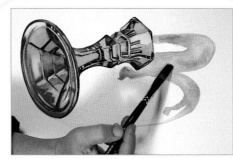

1 APPLY THE FIRST WASH
Mix Permanent Alizarin Crimson and Winsor Blue (Red Shade) using about 50 percent pigment and 50 percent water to get the medium value for the shadow and the first glaze. Paint a wash of pigment, using a ½-inch (12mm) one-stroke. This will be the darkest of the values in the shadow. Load up your brush with as much it will hold without dripping.

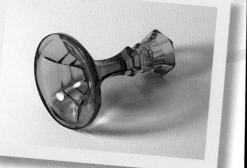

Reference Photo

SUPPLIES

~SURFACE~
140-lb. (300gsm) cold-pressed paper

~BRUSHES~
½-inch (12mm) one-stroke

~PIGMENTS~
Permanent Alizarin Crimson
Permanent Rose
Winsor Blue (Red Shade)

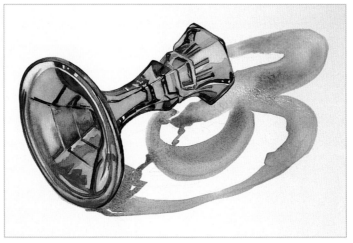

2 DROP IN DARKS
Mix a darker value of Permanent Alizarin Crimson and Winsor Blue (Red Shade), about 75 percent pigment and 25 percent water. While the pigment is still wet, use the ½-inch (12mm) one-stroke to drop in some pigment that is a bit darker in value. Drop paint where you see darker shapes within the shadow. Elaborate; this is a great time to experiment.

3 GLAZE THE SHADOW

Allow the paint to dry completely. Then mix a puddle of Permanent Rose and Permanent Alizarin Crimson. This is a lighter value, so use 90 percent water and 10 percent pigment. With your ½-inch (12mm) one-stroke, glaze over the full surface of the shadow, leaving a dry area on the watercolor paper for the highlights in the shadow.

As you glaze, use the wet-into-wet technique (see page 38) and Permanent Rose and Alizarin Crimson to lay in a variety of values to the wash.

As you are glazing, you may need to soften the edges of the shadow.

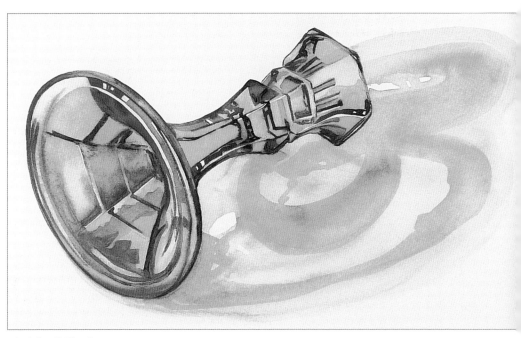

Finished Shadow
Learning to be free with the brush, enhancing what you see in a shadow, will give your shadows extra depth.

Reflections

Reflection is an image that bounces onto a surface that is glossy enough to pick up the image and dense enough to keep the light from penetrating. Reflections come in all shapes and sizes, from color within the shadow to a shape upon the surface of a glass object. They can be as detailed as a mirrored image or as simple as a hint of color.

The reflections of most objects are contorted depending upon the surface they are reflected on. This is a fun aspect of painting; you can get very creative with your shapes. A vase can reflect its surrounding colors and objects, but how those reflections appear depends on the vase's surface and color. Experiment with your still life setup so you can see these reflections and decide if they suit your painting.

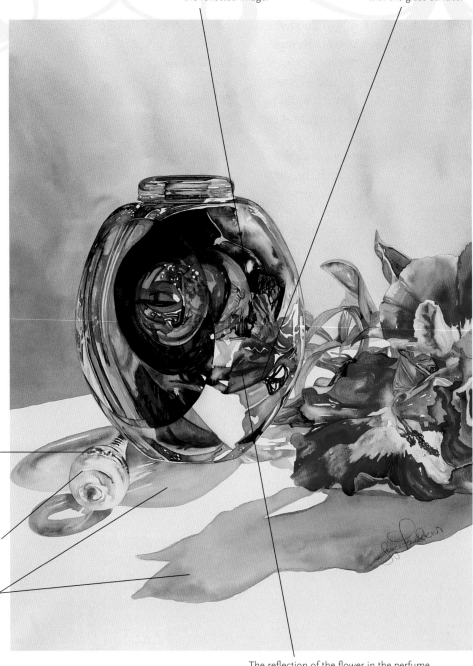

The rich, dark value changes within the flower on the reflective surface help anchor the reflected image.

Let the image curve with the glass surface.

Even though the glass is clear and colorless, there are still dark values. There are also plenty of hard and soft edges that give the lid a sense of density.

The perfume bottle lid is clear, colorless glass, but it reflects colors from the other objects.

The white foam core board reflects the surrounding colors.

The reflection of the flower in the perfume bottle is definitely contorted.

Reflections in Action
Reflections come in all shapes and forms; the key for you, the artist, is to recognize the shapes and not be shy about the dark values.

This painting is a great study in reflective surfaces. The perfume bottle has a glass surface with a finish that appears mirror-like.

SWEET MEMORIES
20" × 26" (51cm × 66cm)
140-lb. (300gsm) cold-pressed paper

Refraction and Distortion

Have you ever noticed how the stems of flowers in a vase appear as though they're breaking apart? This is *refraction*.

A refracted shape is created when light passes through something transparent, such as water or glass, and bends. This bending light creates an optical effect, which gives us the refracted shape. How much the shape is refracted depends on the curve of the glass and whether there is water in the vase. Experiment with any vase. Add water halfway to the top and insert a stem or straw. You will then see the refracted shape.

The "classic" example of refracted light is the prism. Light shines into the prism and, because of the shape of the prism, bends. The prism slows the light down enough that it shows the entire spectrum of colors. Shining a direct light into a faceted piece of glass or crystal will produce this effect.

Distortion happens to any image behind a glass object when it is viewed through the glass. It becomes warped and almost abstract in appearance. If you add water to a glass container, objects behind the container will distort dramatically.

The easiest way to paint a distorted image is to keep the shapes in mind and not the subject. This will help you paint what you actually see rather than a preconceived notion of the subject. The shapes that are created by distortion are frequently very abstract, so much so that it's like looking at an abstract painting. Remember that refraction occurs to the object in the vase and distortion happens to the object behind the vase.

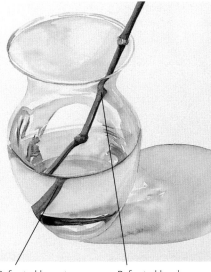

Refracted by water Refracted by glass

Refraction
The water bends the light as it leaves the jar. This changing of light waves makes the stem appear distorted and bent.

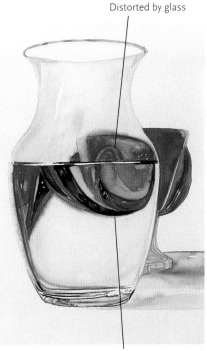

Distorted by glass

Distorted by water

Distortion
Note the increased distortion and magnification that happens to the image that you see below the water line as opposed to above it.

The Prism Effect
Refraction of light is created as light bends when it hits the glass surface, which creates a prism of light. Early morning sun creates the best prism effects through crystal, but you can shine a direct light into any piece of glass and a prism will appear. Note the colors this creates in the crystal. These are among the most fun effects to re-create in your art.

Working With Value, Dark to Light

There is an old saying, "Value does the work and color gets all the credit." *Value* is the lightness or darkness of a hue or shade. Alfred Hitchcock was famous for his use of lights and darks in film to create a feeling of tension, drama and direction. Ansel Adams was known for his use of values in his photographs of national parks.

When painting glass, value is actually more important than color. As long as it has a range of values, the subject will appear transparent (or opaque or dense or thin) regardless of its color. Contrasting your values throughout a painting is the key to creating wonderful light and depth.

Painting dark to light establishes your values early. The contrast of the darkest values next to the lightest gives the glass its radiance, transparency and depth. Planning the placement of the darkest values (and then painting them first) helps organize complex subjects.

The white of the paper will always be your lightest value. The beauty of working with your watercolor paper on stretcher bars is that when you lay down a dark value, that value will not lighten. Be aware, though, that when you lay down that darkest value, it will look like it's jumping off the paper. This effect is only temporary; when the rest of the values are in place, everything will look fine.

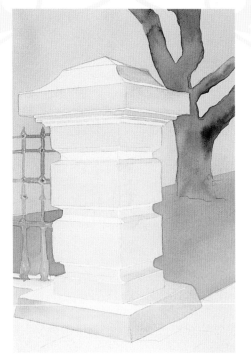

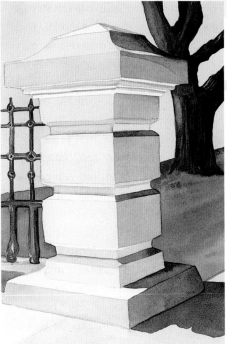

Middle Values Only
With only middle values, the corners and indentations in this pillar virtually disappear, as does the painting. It has no dark values, and therefore no "pop."

Dark Values Create Depth and Light
Do not be afraid of the dark values. The dark values enhance the lights of the pillar and allow those corners and indentations to really "pop."

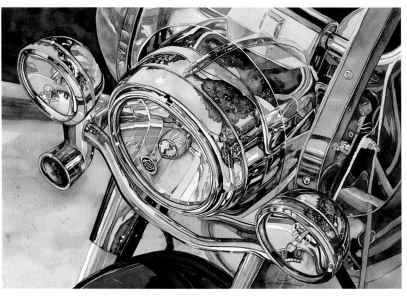

Contrast Equals Shine
The dark-to-light method that works for cut crystal and glass also applies to painting chrome, landscapes or anything that needs to shine. The shine of the chrome is entirely dependent on the amount of contrast you apply; this is also true for the shine of glass.

HARLEY
28" × 20" (71cm × 51cm)
140-lb. (300gsm) cold-pressed paper

Value Scales

A value scale generally has ten steps, from 1 (the lightest value) to 10 (the darkest value). Creating your own value scale is a great exercise in many ways. You learn a lot about working with watercolor, including the blending process; you gain brush confidence; and you become an expert at glazing. Once you create your own scales, you have a value scale bar that you can use to compare values on your paintings and reference materials.

For instance, say you're in the middle of a still life and you are not sure if the red should be a number 5 or 7 value. You would lay your value scale next to the reference photo. Then mix your pigment according to the scale. The advantage is that you will see the process of your values, and you will not go too dark too soon. The disadvantage to this method is that you must let the paint dry completely in between glazes, which is a lengthy process.

LIGHT TO DARK VERSUS DARK TO LIGHT

Painting light to dark is the traditional watercolorist technique. This means glazing many times over to reach your number 10 value. Painting dark to light is a bit different. This means a little more practice for mixing your pigment in the palette. You mix your blackest for number 10 and gently add water to then get your number 9 value and so on. The advantage is that you have your darkest value set in place and can use it as a reference for the rest of the values. It also goes more quickly than glazing. You just need to be sure to leave your lights (white of the paper) for the end.

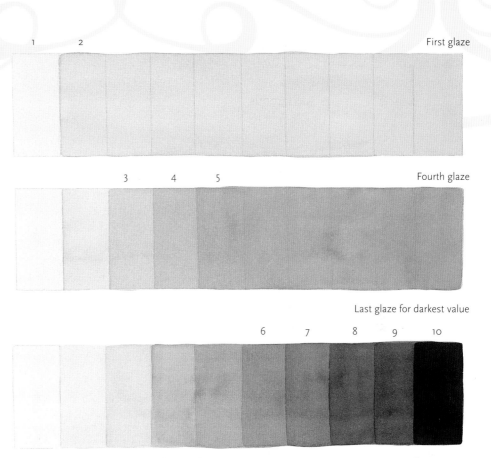

First glaze

Fourth glaze

Last glaze for darkest value

The Traditional Value Scale: Light to Dark

The first square on your scale is the lightest value, which is your white paper. Leave that spot blank and move on to the second square. With a very diluted pigment for your number 2 value, glaze the entire scale from the second spot up. Once this first pass has dried, proceed with the same puddle of pigment into square three. Continue to paint the squares using the same puddle of pigment until the entire value scale is complete. Every glaze will result in a darker value because of the additional layers.

My Value Scale: Dark to Light

Mix your darkest value. Once it's ready, lay it down in the tenth square. For the next value, pull a little pigment from the puddle of paint and add water. Think of water as your white as you go through this process. Continue increasing the amount of water you add to the pigment with each step.

A Color Wheel for Glass and Crystal

Over the years I have discovered certain colors that work well for cut crystal and glass. Of course, there will always be exceptions when I need to add a color or two to my palette, but for most cases I use the same eight colors. This is a great way to keep costs down and simplify your palette while learning a complex subject. Using this simplified palette also forces you to really understand and get familiar with these eight pigments, mixing them to discover various hues.

COMPLEMENTS

Complementary colors are colors that appear opposite one another on the color wheel. Here is an easy way to remember the complementary colors: The three primaries are red, yellow and blue; to get a color's complement, just mix the remaining two. For example, to get the complement of yellow, blend blue and red to get purple. To get the complement of red, blend blue and yellow to get green.

Nature has a great instinct for complementary colors. Just look at flowers: green leaves on a red poinsettia, purple petals and a rich deep yellow on the iris. This is a great lesson to observe and learn—nature does it best.

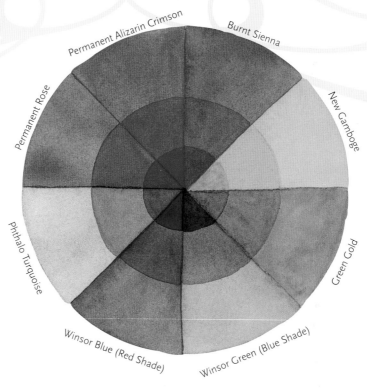

A Crystal and Glass Color Wheel
I have narrowed my pigments down to eight. This doesn't affect the ranges of values or hues that are possible, though!

Complements Primaries

Create Complements From the Primary Colors
Taking just the primary colors of the crystal and glass color wheel, you can discover the complementary colors. The primary colors are Permanent Rose, New Gamboge and Winsor Blue (Red Shade).

Working With Color

Painting a color chart will help you understand the specific paints. You'll understand how the different pigments float on the paper differently, how they work with other colors, and which are transparent and which are opaque. You'll also discover your personal favorites.

PIGMENT QUALITIES

The color charts on this page include information on the qualities of the various pigments. In particular, I find it helpful to know whether pigments are transparent or opaque, and staining or nonstaining.

- **Transparent** pigments can be layered or glazed so you can see the initial layer of paint, and the white of the paper can still bounce through the color. This is a main reason why watercolorists are drawn to this medium. To get deep dark values, generally you will need to add the complementary color.

- **Opaque** pigments do not allow light to come through. I have never found an opaque that I wanted in my palette. While you can always make an opaque pigment transparent by adding water to it, I avoid them altogether because they seem to be chalky and muddy. Do not let this keep you from experimenting, though. You may find you like them.

- **Staining** colors actually bond with or "stain" the surface to which they are applied, making them difficult to remove.

- **Nonstaining** colors lay on top of the material, making them easier to remove, lift and lighten.

Color Combinations Blended
Color Combinations Glazes

Winsor Blue (Red Shade) and Burnt Sienna

Winsor Blue (Red Shade) and Burnt Sienna

Permanent Rose and Green Gold

Permanent Rose and Green Gold

Winsor Blue (Red Shade) and Permanent Rose

Winsor Blue (Red Shade) and Permanent Rose

Green Gold and Phthalo Turquoise

Green Gold and Phthalo Turquoise

Winsor Green and Permanent Rose

Winsor Green and Permanent Rose

Standard Color Chart, Make Your Own

The color charts represent the eight colors I use for cut crystal and glass, plus Quinacridone Gold and Winsor Yellow—two extra yellows that come in handy occasionally. These colors make bright, clean mixes of paint.

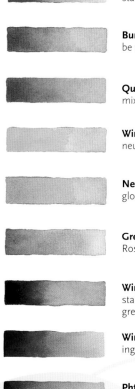

Permanent Rose—Transparent and staining, mixes well with any other color within this palette.

Permanent Alizarin Crimson—Transparent and staining, used to mute other pigments.

Burnt Sienna—Transparent, a color no artist should be without.

Quinacridone Gold—Transparent and staining, mixes well with most pigments.

Winsor Yellow—Transparent and staining, a good neutral yellow.

New Gamboge—Transparent, creates an amazing glow.

Green Gold—Transparent, mix with Permanent Rose to get a color only this mixture can create.

Winsor Green (Blue Shade)—Transparent and staining, a must-have in my palette; will create a teal green to army green.

Winsor Blue (Red Shade)—Transparent and staining, love this blue.

Phthalo Turquoise—Transparent, the only student grade pigment in my palette; just cannot seem to find this shade in any other brand.

Pigment Blends

Here are just a few blends possible with this palette. For better knowledge of the pigments, experimentation is crucial.

Column one is pure color with the two pigments blended in the center of the octagon. Column two is pure color with a glaze of the second color. Remember, to get a good glaze, allow the first color to dry completely.

Temperature

When you think about the temperature of a color, think about what it would feel like. For instance, greens and blues are generally considered cool—think of how grass and swimming pools feel cool to touch. Now think of the something warm, such as the sun (yellow) or hot coals (orange). For practice, look at a painting and look for colors that seem difficult to classify as cool or warm. Then relate those colors to a familiar object that you could touch and be sure of the temperature.

Cool Colors

Permanent Alizarin Crimson—Cool red, excellent for muting other pigments.

Winsor Green (Blue Shade)—Cool, deep and intense.

Winsor Blue (Red Shade)—Cool, mixes well with all the pigments.

Phthalo Turquoise—Cool, exceptional for most highlight seen in cut crystal and glass.

Warm Colors

Permanent Rose—Hot pink, add a little Winsor Blue to cool down.

Winsor Orange (Red Shade)—Very warm, luminous.

Burnt Sienna—Warm, great color straight out of the tube or to mix.

New Gamboge—Warm, glowing.

Quinacridone Gold—Very warm.

Winsor Yellow—Warm, soft and sparkling.

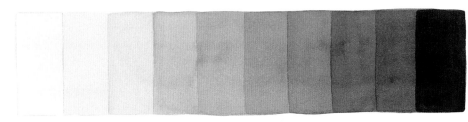

Green Gold—Warm, pale, use occasionally.

Making Grays

To make a gray, you need to mix two complementary colors. To control the gray's temperature, you need to consider the temperature of its components. The combination of pigments I prefer for grays is Permanent Alizarin Crimson and Winsor Green (Blue Shade). For a neutral gray, create a mixture of 60 percent Permanent Alizarin Crimson and 40 percent Winsor Green (Blue Shade).

For a warmer gray, add more red. The mixture above is 70 percent Alizarin Crimson and 30 percent Winsor Green (Blue Shade).

For a cooler gray, a mixture of 50 percent Winsor Green and 50 percent Alizarin Crimson is good. This green overpowers the red, so an equal mixture will lean toward the cool greenish side.

DON'T CHAIN YOURSELF TO ONE PALETTE

Winsor Orange (Red Shade) is generally not in my palette. But as I discover a beautiful piece of glass, sometimes I need to wander outside my usual realm. If you're not finding what you need in the palette you have, don't hesitate to hunt elsewhere for the perfect pigment for that piece of glass.

USING TEMPERATURE

Here are a couple of rules to guide your use of temperature.

- Balance warms and cools in your painting. Try using a percentage formula, such as 25 percent cool and 75 percent warm.

- Warm colors, such as red, yellow and orange, will come forward on the painting, which may be where you place the focal point.

- Cool colors, such as blue, green-blue and violet, will recede on a painting, making them good colors to use to glaze in areas that need to recede.

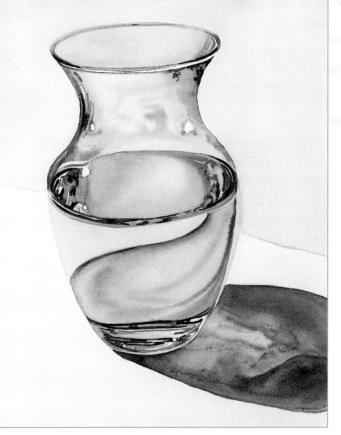

A Cool Subject
The dominant temperature of this clear glass jar is cool. I added the touches of warmth to bring some excitement into the painting. The cool colors used for the clear jar and the shadow are Winsor Green (Blue Shade) blended with Permanent Alizarin Crimson. For the warm colors, I relied on Winsor Orange (Red Shade) and New Gamboge.

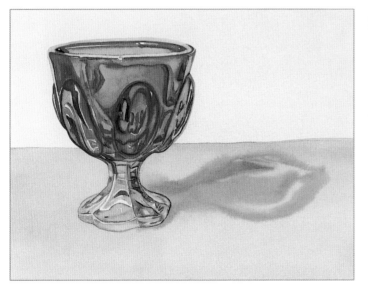

A Warm Subject
The dominant temperature of this candy jar is very warm, but the shadow is cool. Paints used in the candy jar are Winsor Orange (Red Shade) and New Gamboge. The gray of the shadow is a blend of Phthalo Turquoise and Winsor Orange (Red Shade). Since Phthalo Turquoise has a touch of green, these colors act as complements. To make the gray cool enough to contrast with the warm candy jar, the gray mixture has more cool Phthalo Turquoise than Winsor Orange (Red Shade).

A COOL RED?

Reds and yellows are not always warm, just as some blues are not always cool. A pigment such as Alizarin Crimson contains enough blue to actually create a cooler red. And a Blue-Violet may very well be teetering on the warm side of blue.

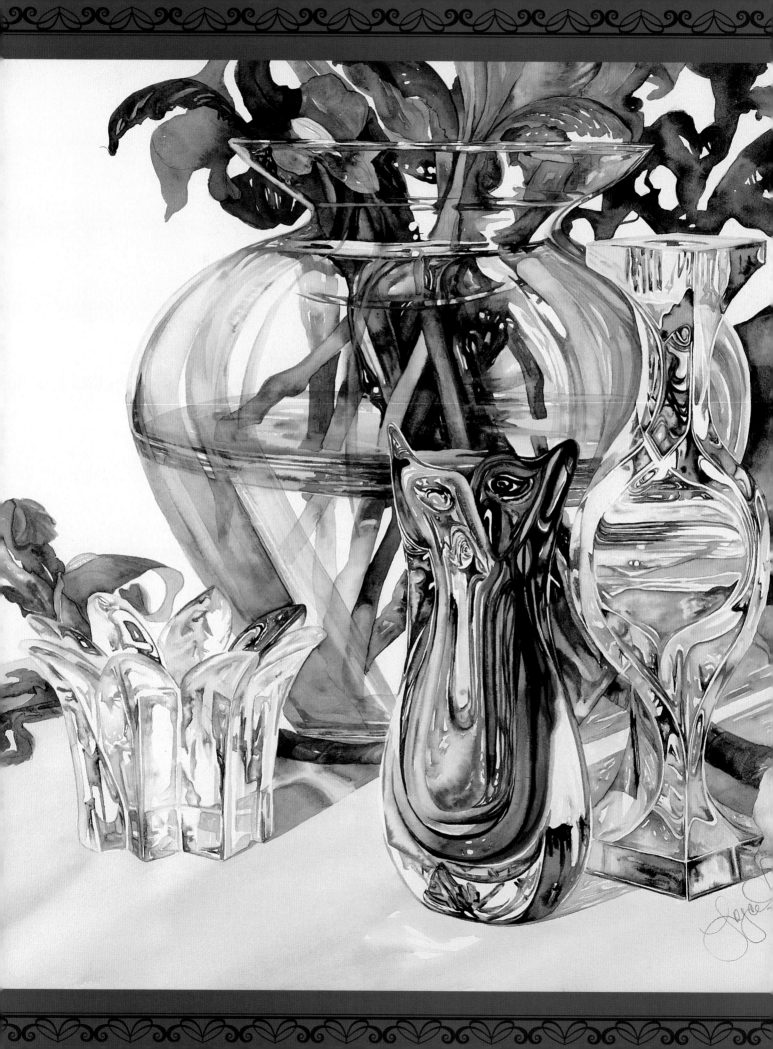

3 TECHNIQUES FOR CRYSTAL AND GLASS

Learning techniques with crystal and glass can be fun. Let's say you find a simplistic piece of cut crystal with many diamond-cut shapes. The diamond shapes repeat all around the crystal. Creating all the diamond shapes makes a great exercise, but at the end of the exercise instead of having a paper full of repetitive shapes you have a finished painting of one or two pieces of glass.

In this chapter you'll learn the simple techniques that you'll use to incorporate glass into your paintings. They're easy enough that you'll start creating stunning pieces almost immediately.

DIANA'S GIFT
28" × 20" (71cm × 51cm)
140-lb. (300gsm) cold-pressed paper

Wet-Into-Wet

Wet-into-wet is the ultimate technique to learn once you begin painting in watercolor. It's basically adding paint to a surface already wet with water. The *amount* of water is what determines how the paint will look once it is dry. This technique is great for creating a smooth surface without any brushstrokes. You can also just drop in color and let the water and pigment mix to create their own shapes and designs.

Because the wetness of the paper is the key to controlling the pigment, you need to have a good idea of the amount of water on your paper and brush to make the pigment float or flow. The best way to determine the wetness of your paper is to check for shine. Sometimes the shininess is hard to detect; holding the paper at eye level to check from the side frequently helps. *Damp* paper will have a dull shine; *moist* paper will be quite shiny; and really wet paper, well, there will be a *puddle*.

Have your pigments blended and ready to go before beginning any-wet-into-wet technique. You want to be able to wet the paper and apply the pigments immediately. If you wet the paper and then step back to blend your pigments, your paper will begin to dry.

Check for Shine
Get eye level with your paper to determine if it's the correct wetness.

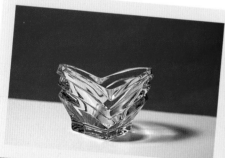

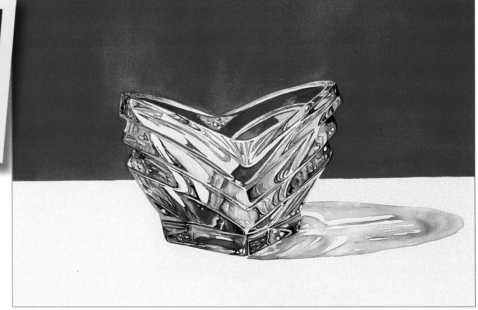

**Discovering
the Technique From a Reference
Photo**
Notice all the soft edges and swirled colors? Based on the reference photo, I knew that wet-into-wet would be the primary technique. In fact, about 80 percent of this painting relies on the wet-into-wet technique.

BLOSSOMS

Blossoms occur when you lay a wet brush onto a very wet surface with pigment already on the paper. Use them to add texture, such as an adobe wall, to your background.

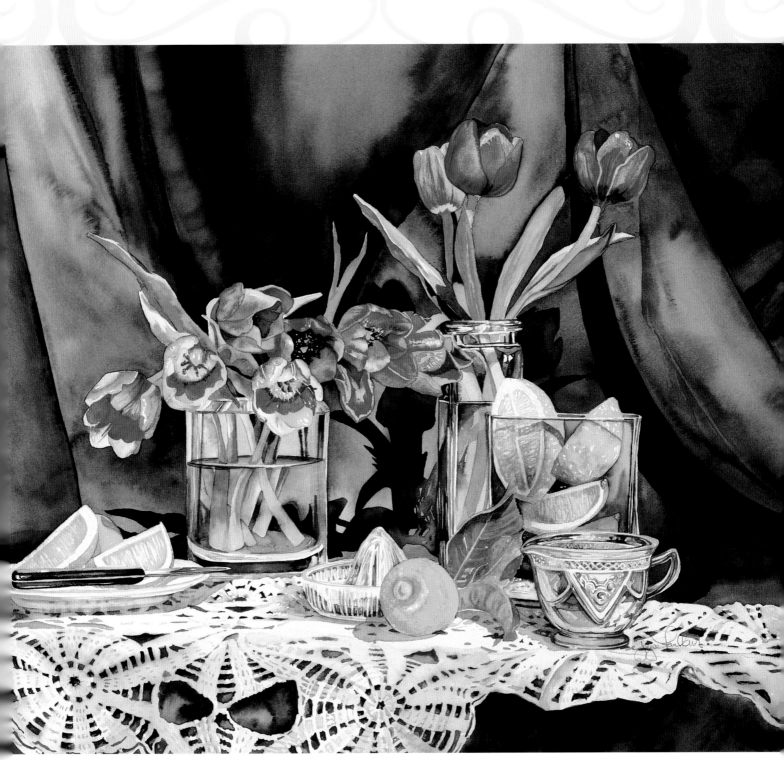

The wet-into-wet technique helped create the softer edges of the fabric folds in this background, as well as within the lace's eyeholes.

MY GRANDMOTHER'S LACE
22" × 18" (56cm × 46cm)
140-lb.(300gsm) cold-pressed paper

EXERCISE
Classic Wet-Into-Wet

This exercise will help you manage and use the different pigment-to-water ratios: damp, moist and puddled. Just remember that pigment flows faster with more water and slower with less water.

SUPPLIES

~SURFACE~
140-lb. (300gsm) cold-pressed paper

~BRUSHES~
No. 6 round

~PIGMENTS~
New Gamboge
Permanent Alizarin Crimson

~OTHER~
HB pencil

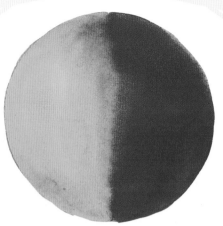

Wet-Into-Wet on a Damp Surface

A damp surface has only a dull shine but is still wet enough to have a slight effect on the pigment.

To practice, mix two puddles—one of Alizarin Crimson and one of New Gamboge. The consistency should be creamy. On your paper, draw a circle with a line down the middle. Apply clear water on the entire circle and allow the paper to absorb the water. Determine how wet the paper is. For this variation of wet-into-wet, you want a damp surface with a dull shine. Paint half the circle Alizarin Crimson and half New Gamboge.

Wet-Into-Wet on a Moist Surface

Draw another circle and draw a line through the middle, then wet this circle with clean water. Check to see if the paper is moist. It may not be obvious, so hold the paper at eye level to check from the side. The paper should have a glossy shine, but not a puddle. For an even flow of pigment, be sure the water is evenly distributed.

Using the same pigments as before, paint half the circle Alizarin Crimson and immediately paint the other half New Gamboge. Because the paper is wetter than the damp surface, the central line will not be as controlled and the colors will bleed into each other.

Wet-Into-Wet on a Puddled Surface

As with the previous examples, draw a circle and then draw a line through the center. Wet the surface so that the clear water appears to be a puddle. Using the Alizarin Crimson and New Gamboge left on your palette from the previous exercises, add the color to the circle. Drop some Alizarin Crimson onto the right side of the circle, then drop New Gamboge onto the left side. Let the pigment float.

There is little or no control with this technique. The most difficult part may be stepping back; you'll instinctively want to disturb and direct the paint. The natural end result can be just what you wanted, though.

Wet-Into-Wet Variations

This wet-into-wet variation is a wonderful technique for blending pigments with control and predicting the outcome. Blending two colors while the paper is wet is a bit tricky, but well worth the time to practice. And working wet-into-wet with a colored wash is great for keeping your colors from becoming muddy.

SUPPLIES

~SURFACE~
140-lb. cold-pressed paper

~BRUSHES~
No. 6 round

~PIGMENTS~
Winsor Blue (Red Shade)
Winsor Green (Blue Shade)

~OTHER~
HB pencil

Wet-Into-Wet on a Colored Wash

You want your bottom wash to be Winsor Green (Blue Shade) and the top wash to be Winsor Blue (Red Shade). Mix these paints before the paper is wet, but make sure the Winsor Blue is the thicker of the two (this will help prevent blossoms). Begin this technique with a wash of Winsor Green (Blue Shade) over the entire circle. While the Winsor Green is still wet, immediately paint the lower right half with Winsor Blue (Red Shade). Allow the paint to run together. You can control the shape of the Winsor Blue to a degree, but don't overwork it.

Wet-Into-Wet on a Colored Wash With Various Values

Begin with a wash of Winsor Green (Blue Shade). While the Winsor Green is still wet, lay in your darkest value of Winsor Blue (Red Shade). With a clean, dampened brush, pull pigment from the dark value into the light value. Repeat this process until you have a middle value between the darkest and lightest values.

Wet-on-Dry

Painting wet-on-dry involves laying paint down on dry paper and then pulling the pigment with a damp brush to expand paint throughout the shape. The wet-on-dry technique can look similar to wet-into-wet, but it offers a little more control. It works well for small areas where the wet-into-wet technique may oversaturate an area.

Again, the amount of water on your brush and paper is the key to success. Not only are you and your brush doing the work, but your water and paper towels are, too.

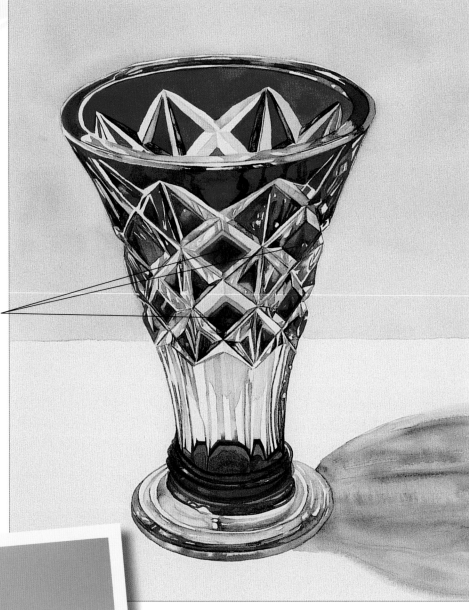

Wet-on-dry

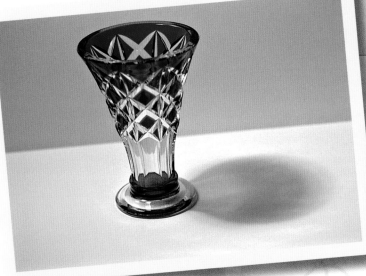

Scarlet Crystal Vase
Using the wet-on-dry technique within each diamond shape allowed me to control the value changes within the shapes of this scarlet cut crystal vase .

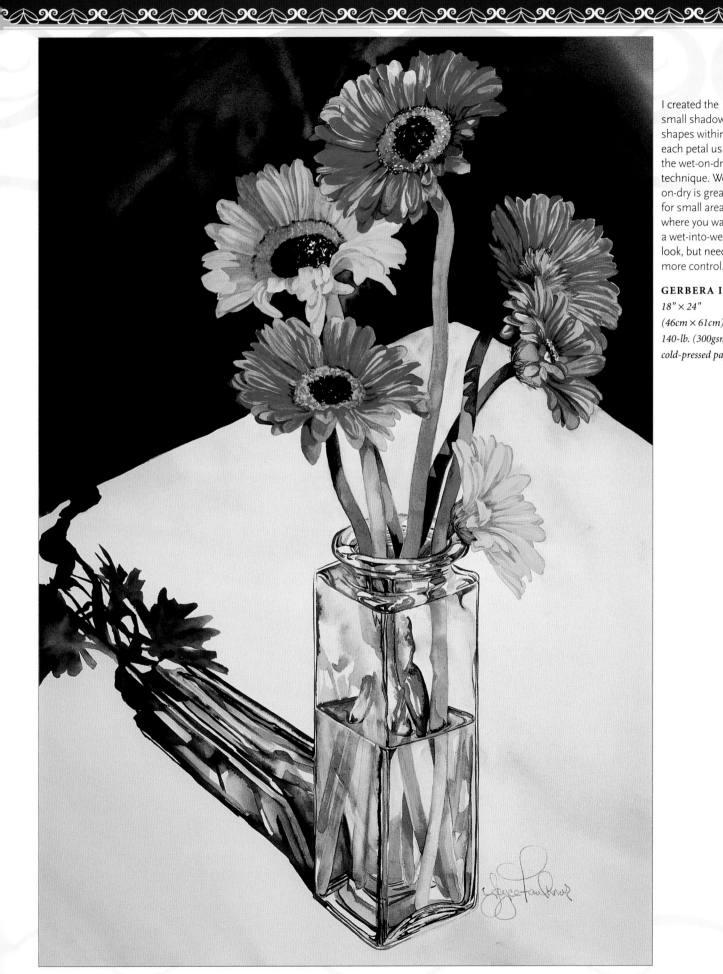

I created the small shadow shapes within each petal using the wet-on-dry technique. Wet on-dry is great for small areas where you want a wet-into-wet look, but need more control.

GERBERA II
18" × 24"
(46cm × 61cm)
140-lb. (300gsm)
cold-pressed paper

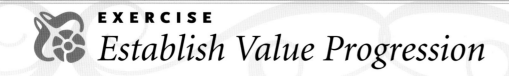

EXERCISE
Establish Value Progression

Sometimes cut crystal has a distinct hard edge on the outside, but within are shapes that contain gradations of dark to medium to light values. In this exercise you'll practice creating these three values: dark at the top, medium in the center, and light at the bottom.

SUPPLIES

∽SURFACE∽
140-lb. (300gsm) cold-pressed paper

∽BRUSHES∽
¼-inch (6 mm) flat

∽PIGMENTS∽
Permanent Alizarin Crimson

∽OTHER∽
HB pencil
Ruler

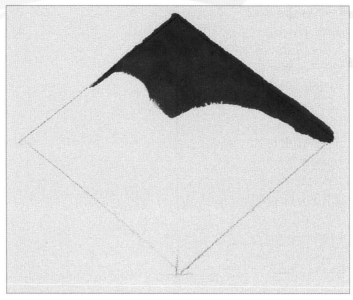

1 PAINT THE DARKEST VALUE
Draw a diamond shape on your paper. Use a ruler to keep your lines straight. Mix your pigment. Keep it fairly thick, about 25 percent water to 75 percent pigment. Load a clean ¼-inch (6mm) flat, then apply the first paint to the top of the diamond shape. Clean your brush thoroughly.

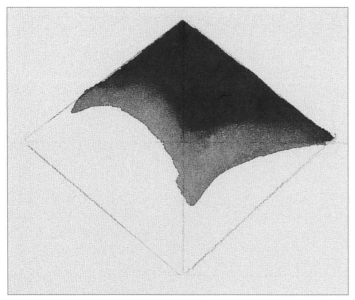

2 CREATE THE MIDDLE VALUE
Make sure your brush is damp (but not dripping wet), then pull the pigment from the top into the center of the diamond. Rinse your brush again.

3 CREATE THE LIGHTEST VALUE
Repeat the previous step, dragging pigment from the center to the bottom of the diamond.

EXERCISE
Mingling Saturated Color

Painting crystal often involves simulating the effect created when light penetrates dense glass. To accomplish this, you need to become proficient at joining two values to create a lighter value in the middle.

In this exercise you'll practice with two puddles of paint mixed with just Permanent Alizarin Crimson. You'll begin with the top lighter than the bottom, then create a still lighter value in the middle. You'll also find yourself using this technique as you create highlights.

SUPPLIES

~SURFACE~
140-lb. (300gsm) cold-pressed paper

~BRUSHES~
¼-inch (6mm) flat

~PIGMENTS~
Permanent Alizarin Crimson

~OTHER~
HB pencil
Ruler

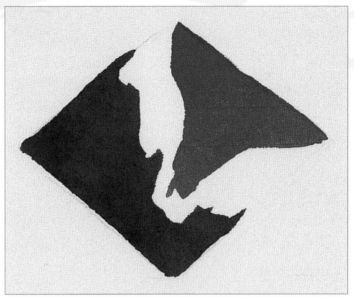

1 PAINT THE TOP AND BOTTOM COLORS
Draw a diamond shape on your paper. Paint the top third with a medium-dark value of the Permanent Alizarin Crimson. Using a clean brush, paint the bottom third of the diamond the dark value. Clean your brush.

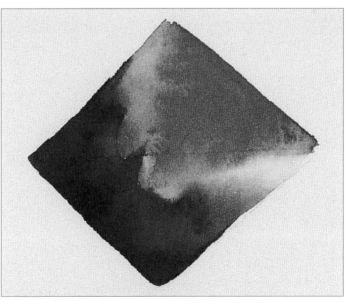

2 JOIN THE TOP AND BOTTOM COLORS
While both areas are still wet, use a damp brush to pull color from both areas into the center of the diamond. The center area will act as your light value, and you'll achieve some wonderful, soft edges.

Glazing

Glazing is the layering of thin applications of paint. You allow each layer to dry before applying the next. You can glaze to change the temperature within a painting, to achieve a darker value, to alter the hue by painting colors over one another, or—for glass objects—to lay the lightest values. This final glaze is how you achieve curve and shine.

Perfume Bottle
I painted the perfume bottle primarily using a dark-to-light glazing technique. Repeated glazes in the same area will give you an effect that looks as if there were depth to the paint and much movement in the painting.

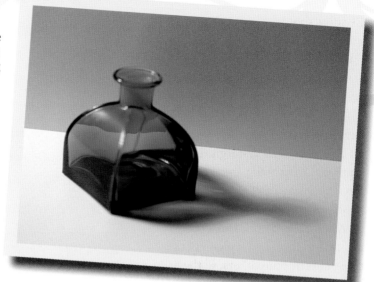

To alter the temperature from the cool Winsor Green (Blue Shade) wash, I waited for it to dry and then applied a wash of the warmer pigment, New Gamboge. This changed the cool green to a warm green.

Repeated glazes of transparent washes lend a feeling of circular movement to the opening of the bottle.

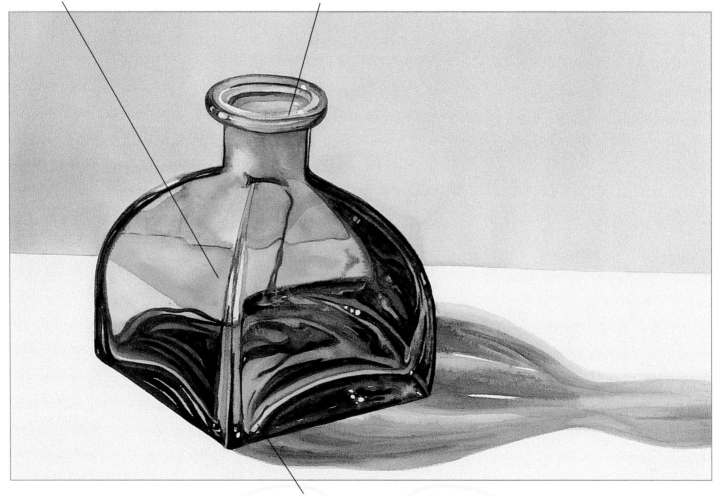

Corners of most glass pieces become thicker and heavier. I glazed each layer using different values of dark against light to get that heavy look that really makes the glass shine.

Testing for Values

Because glazing requires that you layer paint to achieve values, you need a frame of reference to ensure that you get the values you want. This reference will eliminate some of your guesswork.

To do this you'll need to create a test strip before you begin painting, and use it to test throughout the glazing of your painting. It may seem like extra work, but it will familiarize you with how much water to add and how particular pigment combinations behave. All hues react differently. Some pigments are more intense than others, so the testing is a great kickstart to understanding the pigment. Be sure to use the same pigments and paper on the strip as you do on the painting.

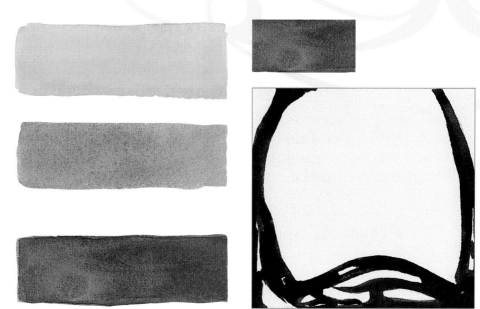

Creating a Test Strip

Using a 3" × 10" (8cm × 25cm) strip of 140-lb (300gsm) cold-pressed paper, create a test strip of the values you plan to use before you begin painting. Once the strip dries, you can easily use it as a gauge for values on your painting. Keep this next to you while mixing pigments.

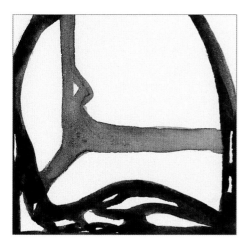

Repeat the Testing for Each Value

After your first glaze dries, add water to the batch of premixed pigment for the next lightest value. Add that to your painting. Once the new value dries, hold the test strip next to it to check. Simply adjust the values until they match the test strip.

EXERCISE
Glazing Light to Dark

Glazing light to dark is the traditional method for watercolorists. By practicing this exercise you will gain understanding of how dark your glazes can get.

On your palette, mix a large puddle of Permanent Rose and Winsor Blue (Red Shade). Be sure the mixture is very diluted, about 90 percent water and 10 percent pigment. You'll use the same puddle of pigment throughout this exercise, so be sure to mix a large batch.

SUPPLIES

~SURFACE~
Arches 140-lb. cold-pressed paper

~BRUSHES~
1/2-inch (12 mm) one-stroke

~PIGMENTS~
Permanent Rose
Winsor Blue (Red Shade)

~OTHER~
HB pencil
Ruler

1 GLAZE YOUR LIGHTEST VALUE
Draw a square on your paper. Use diagonal lines to divide the square into four equal parts. With your brush, glaze the entire square with an even wash of the purple mixture. Let it dry thoroughly.

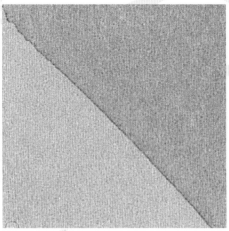

2 GLAZE THE LIGHT MIDDLE VALUE
Glaze the upper right part of the square with another layer of the same purple mixture. This area will appear slightly darker. Let everything dry.

3 GLAZE THE DARK MIDDLE VALUE
Except for the lightest triangle to the left, glaze everything with another wash of the purple mixture. Allow everything to dry thoroughly.

4 GLAZE THE DARK VALUE
Glaze the topmost triangle with one last wash of the purple mixture. The final square should now begin with the lightest value on the left and go counterclockwise to the darkest value.

Glazing Dark to Light

Practice this exercise to get ready for painting glass. As a watercolorist, you have to have the confidence to lay down your darkest value first. It can be a little intimidating, but with a little practice—and some reassurance that this method *does* work—it will become easy.

On your palette, mix Winsor Green (Blue Shade) with a hint of Burnt Sienna for a rich, dark value. Throughout this exercise, you'll be pulling from this pigment and adding water to it to create lighter and lighter values.

SUPPLIES

~SURFACE~

140-lb. cold-pressed paper

~BRUSHES~

No. 6 round

½-inch (12mm) flat

~PIGMENTS~

Burnt Sienna

Winsor Green (Blue Shade)

~OTHER~

HB pencil

1 PAINT YOUR DARKEST VALUE

Draw a square. Within that square, draw the shapes representing your darkest value. Glaze these shapes with paint directly from the full-strength mixture on your palette using the no. 6 round. Let everything dry thoroughly.

2 GLAZE YOUR DARK MIDDLE VALUE

With your pencil, draw the dark middle value shapes. Pull pigment from the full-strength mixture with your no. 6 round and dilute it with a little bit more water. Test it to be sure you've mixed the correct value. Glaze the dark middle value shapes with this new mixture. Allow everything to dry.

3 GLAZE YOUR LIGHT MIDDLE VALUE

Consider where to place your light middle values, then draw them in. Again, pull pigment from the full strength mixture and add even more water. Test this mixture; it should be lighter than the previous value when it dries. When you're satisfied with the value, glaze the light middle value shapes with this new mixture. Allow everything to dry.

4 GLAZE THE LIGHTEST VALUE

For the final glaze, make a very light, diluted mixture with pigment pulled from the full-strength mixture. Load your ½-inch (12mm) flat, then gently glaze the entire square, including the pre-painted shapes.

Hard & Soft Edges

Hard edges are just that, abrupt lines between one area and another. Soft edges have more diffused, less distinct lines between areas. Using both is frequently necessary when painting glass and crystal.

For instance, on the beveled edge of the candlestick, the hard edges occur anywhere the plane of the glass changes direction. The hard edges draw the viewer's attention and give the glass focus. The soft edges, found in the reflective shapes within the glass, provide resting points for the eye.

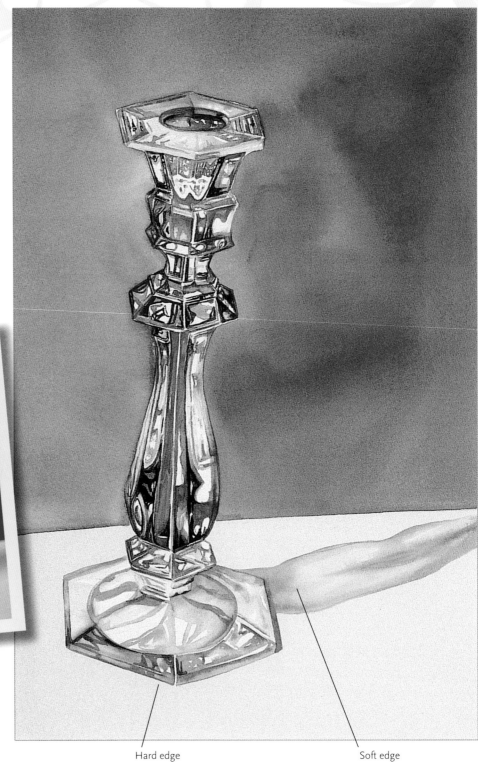

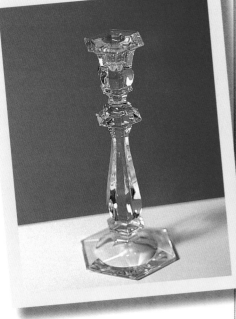

Candlestick Painting
I used both hard and soft edges in this painting.

Hard edge Soft edge

PRESERVING HARD EDGES

To make sure your hard edges remain hard, be sure to leave the paper dry next to the edge in question. The pigment will stay still and create that edge.

Softening Hard Edges

Because most glass subjects contain both hard and soft edges, you'll often find yourself in situations where you need to begin with hard edges and move to softer ones. This occurs with those shapes that appear in the corners of bottles and at the bases of some square vases, where the glass is dense in the corner then becomes more transparent as it moves upward. These exercises will give you some practice with these transitions.

The first exercise uses an edge that's preplanned. The second is useful for those cases in which you need to rescue a soft edge that you may have missed.

SUPPLIES

~SURFACE~
140-lb. (300gsm) cold-pressed paper

~BRUSHES~
¼" (6 mm) flat

~PIGMENTS~
Winsor Blue (Red Shade)

~OTHER~
HB pencil
Ruler

PLANNING A HARD TO SOFT TRANSITION

1 PAINT A JAGGED HARD EDGE
Draw a square with your pencil. Mix your pigment, keeping it fairly thick. Paint the top corner of the square. Don't worry about the line or the shape of the paint too much; just keep it jagged. Clean your brush thoroughly.

2 SOFTEN THE WET HARD EDGE
While the pigment is still wet, brush a damp brush just across the edge to loosen it. This should pull a touch of pigment into the central area of the square. Clean your brush once more. With your damp brush, brush over the edge of the central lighter area of pigment, drawing just a bit more color farther into the white. It should look as if the color disappears into the white.

RESCUING A SOFT EDGE

1 PAINT A CURVED HARD EDGE
Draw a square. Mix your paint thickly so the value will be very dark. Again, paint the pigment in the top right corner of the box. Control the shape so that you have a clean, curving line. Allow the shape to dry.

2 SOFTEN THE DRY HARD EDGE
Once the paint is completely dry, loosen the edge with a clean, damp ¼-inch (6mm) flat. Pull the pigment into the white of the paper.

Value Contrast

Strong value contrast not only gives glass its depth but also establishes a sense of light. Placing a light next to a dark will make the glass appear both more real and more dramatic. When you observe your cut crystal subjects, look for the strong value contrasts. You'll find them throughout the piece.

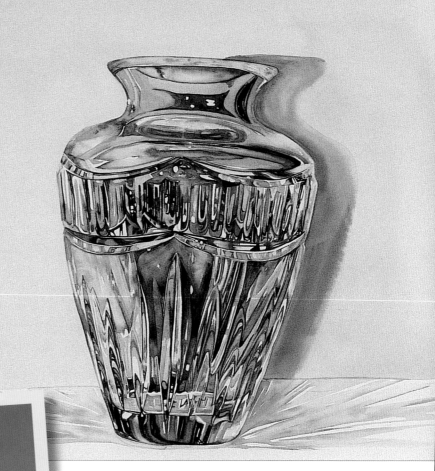

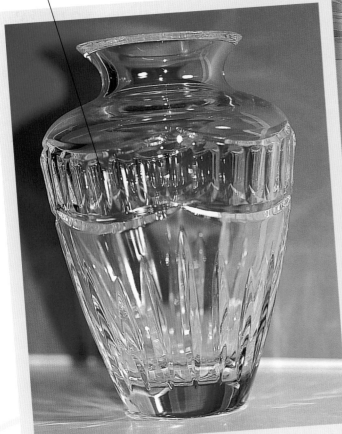

Value contrast

Cut Crystal

Observing cut crystal's diamond shapes is a great way to familiarize yourself with seeing value contrasts. One side of the diamond shape is always darker than the other. Having value contrast helps shape the cut crystal and gives it a wonderful illusion of depth and of light sparkling through.

Establishing a Range of Values

Cut crystal is dark on one side and lighter on the other. The darker side has the two darkest values and the lighter side has the two lightest values. Learning to paint this basic cut crystal is the main key to painting a whole piece. Once you master the basics, you will be able to add to your value range.

The blues used here are exaggerated so you can easily detect the range.

SUPPLIES

∼SURFACE∼
140-lb. (300gsm) cold-pressed paper

∼BRUSHES∼
No. 6 round
¼-inch (6mm) flat

∼PIGMENTS∼
Permanent Alizarin Crimson
Winsor Blue (Red Shade)

∼OTHER∼
HB pencil

1 START BUILDING THE VALUE CONTRAST

Draw in the shapes with a pencil. Using your no. 6 round, paint the darkest value shapes with the full-strength mixture of Permanent Alizarin Crimson and Winsor Blue (Red Shade).

2 CONTINUE BUILDING THE VALUE CONTRAST

Using your ¼-inch (6 mm) flat, pull some pigment from the full-strength mix and dilute it with water for a medium to dark value. Use this to paint the middle values.

3 FINISH BUILDING THE VALUE CONTRAST

Using your ¼-inch (6mm) flat again, pull more pigment from the full-strength mixture and lighten it even more. This mixture should probably be mostly water. Paint this into the light middle value shapes on the *right* side of the diamond shape.

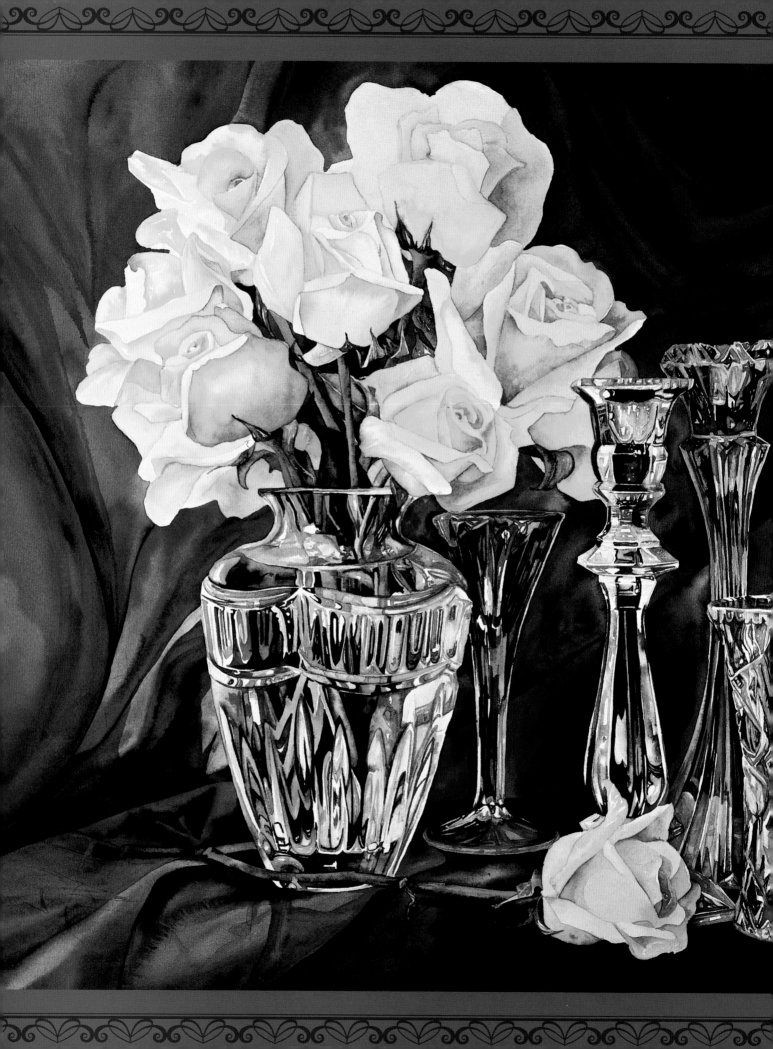

4 CAPTURING GLASS AND LIGHT:
STEP-BY-STEP DEMONSTRATIONS

Painting any glass subject can seem overwhelming. This chapter is designed to eliminate the complexity of the subject and to simplify the shapes. Following the dark to light method will help you build a great foundation for your values. As you learn to trust this process you will become a more confident—and more successful—painter!

LEMON & ICE
22" × 30" (56cm × 76cm)
140-lb. (300gsm) cold-pressed paper

Shapes and Colors in Glass and Ice

A clear glass filled with ice and water at first seems like a subject with no color. But combine these items with a rich dark background and you will see that they are filled with shapes and colors.

The reflective color creates the shapes. Organizing a complex subject is key. To practice this, you'll break down the glass with ice water into three parts: the ice above the rim of the glass, the ice below the rim of the glass, and the ice and water below the water line.

SUPPLIES

~SURFACE~
140-lb. (300gsm) cold-pressed paper

~BRUSHES~
No. 6 round
¼-inch (6mm) one-stroke,
1½-inch (38mm) one-stroke

~PIGMENTS~
New Gamboge
Permanent Alizarin Crimson
Permanent Rose
Phthalo Turquoise
Winsor Green (Blue Shade)
Winsor Yellow

~OTHER~
HB pencil
Transfer paper
Eraser

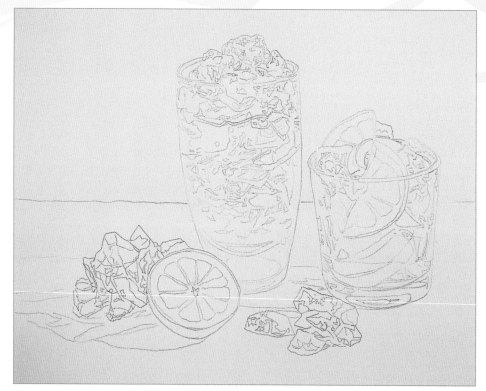

1 CREATE A DETAILED DRAWING
Draw in every detail you can to make the shapes very obvious. Make any desired adjustments to the drawing at this time, too. For example, in the line drawing, I made the chunk of ice behind the lemon smaller than it appears in the reference photo to create some variety.

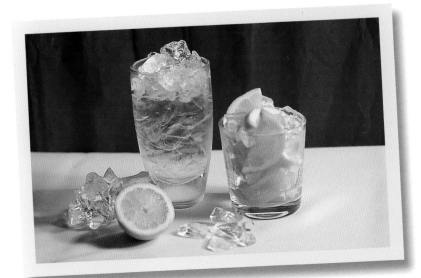

Reference Photo
We know the glass and the ice water are clear, yet bright colors still reflect in and around them. This is what you will paint.

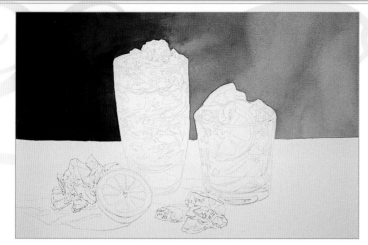

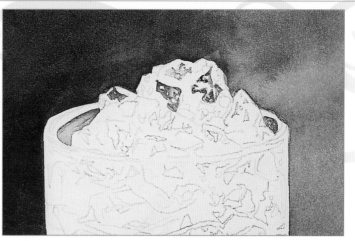

2 BEGIN THE BACKGROUND

Paint the background first to help you define the color that you will see in the glass and the ice cubes. Mix Permanent Rose and Phthalo Turquoise to get a dark reddish purple. I changed the color from what appeared in the reference photo to get a better complement to the New Gamboge.

Apply a graded wash to the entire background with a 1½-inch (38mm) one-stroke. Start with the darkest side of the background, then add a hint of water to lighten the pigment for the lighter side of the background.

3 BEGIN THE ICE ABOVE THE GLASS RIM

Use the same reddish purple mixture and your no. 6 round to paint all the dark shapes in the ice and the top rim of the glass. Show the clarity of the shapes. It is a labor of love, for sure, but well worth the effort. You are building a foundation for your painting. Do not paint the darkest shapes all one value, and allow the white of the paper to be exposed occasionally. This will give the ice a sparkle effect.

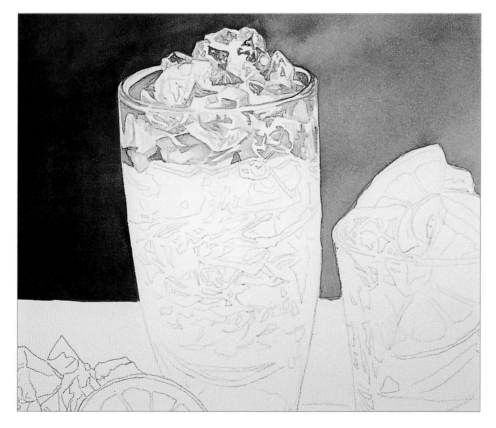

4 PAINT THE ICE BELOW THE GLASS RIM

The ice below the rim changes from a dark reddish purple to a blue-gray. Create the blue-gray color by mixing Permanent Alizarin Crimson, Winsor Green (Blue Shade) and a hint of Phthalo Turquoise. Intertwine the two colors where they seem to meet in the reference photo. Leave the lighter values and the *hot spots* (whitest whites) on the ice for the last part of the painting, the glazing.

5 PAINT THE ICE AND WATER BELOW THE WATER LINE

A lighter value outlines the shapes of the ice and water below the water level, and the colors and values are a bit more muted in general under the water level. Adjust your values as you paint these shapes. The values will become even lighter as the shapes reach the bottom of the glass. The ice shapes become smaller, too, allowing more of the outlines of the ice to show.

Still using the dark reddish purple to bluish gray, wet the area and drop in the color with the no. 6 round. This will create light values and blurry shapes, which is what you want.

Take frequent breaks and stand back from your painting to evaluate your values.

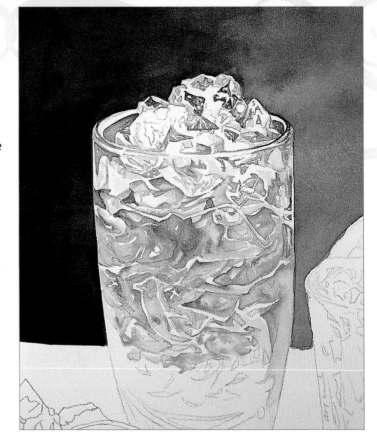

6 ERASE PENCIL LINES AND ADD POP

Once the pigment is "bone dry," erase any pencil marks. Then, still using your no. 6 round, detail shapes that may need hints of darker values, either because there are darker values in the reference photo, or just because you need a little variety. Make some areas pop and make the background ice recede. Lay in washes of the reddish purple for the upper area, and bluish gray for the lower portion.

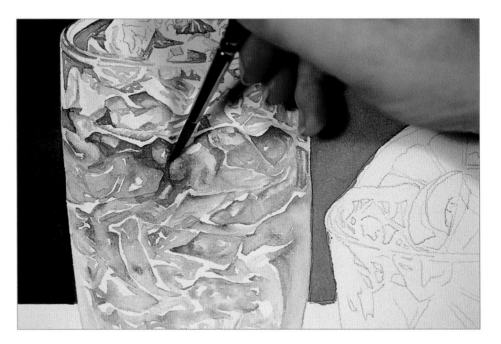

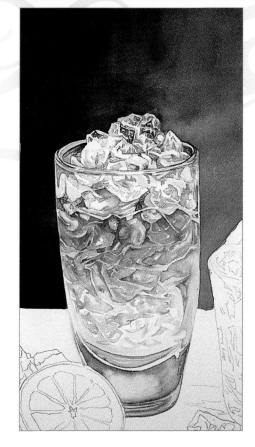

7 PAINT THE BOTTOM OF THE GLASS AND SHAPE THE ICE CUBES

The bottom of the glass is very dense. The distorted shapes are from the background. Notice the beautiful blue on the outer shape in the reference photo.

Use the wet-into-wet technique and the ¼-inch (6mm) one-stroke to lay in a light blue wash on the inside of the glass bottom. While that wash is still wet, outline its shape using a stronger pigment mixture of the reflective background color (see step 2) and a no. 6 round.

Allow the paint to dry. Refer to the reference photo and use the same brush to add a hint of the blue-gray (that's the Winsor Green [Blue Shade], Permanent Alizarin Crimson with a hint of Phthalo Turquoise mixture) to help create the shapes of the lightest ice cubes. Leave the white of the paper for the highlights.

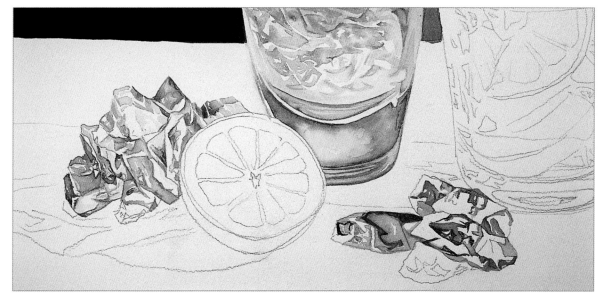

8 GLAZE THE ICE CUBES ON THE TABLE

Use your ¼-inch (6mm) one-stroke and the same blue-gray color to form the ice cubes on the table. Remember, leave the lightest values. You will glaze those at the end.

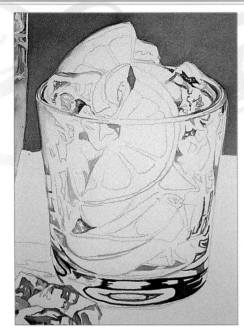

9 PAINT THE DARKS ON THE SMALLER GLASS

Paint dark to light to set up your glass for the glazing. There are only a small number of dark shapes for this portion. Mix a dark value of the reddish purple using Permanent Rose and Phthalo Turquoise. Add Winsor Green (Blue Shade) for the dark gray values. You'll define the lemon with the gray shapes.

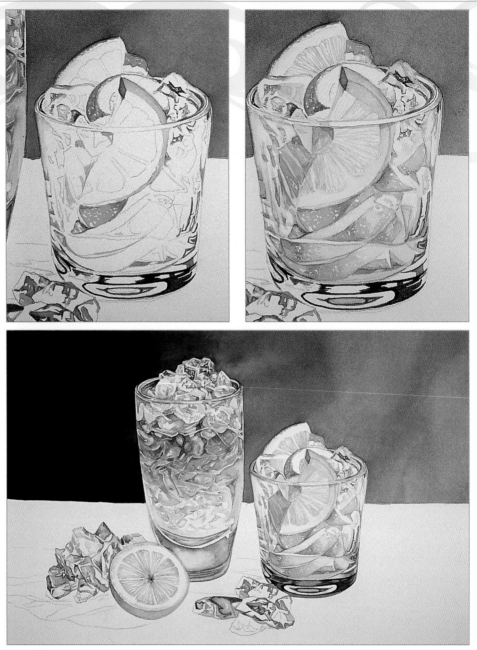

10 PAINT THE LEMONS

Use the wet-on-dry technique and your no. 6 round to mix New Gamboge and Winsor Yellow for the rich yellow of the lemon rind. Punch up the darkest edge with a hint of Permanent Rose. A subtle transition from dark to light will be easy to control. Lighten the tint of the mixture to paint the flesh of the lemons.

To finish the bottom rim of the glass, use your no. 6 round and the darkest value to follow the shapes you see in the reference photo.

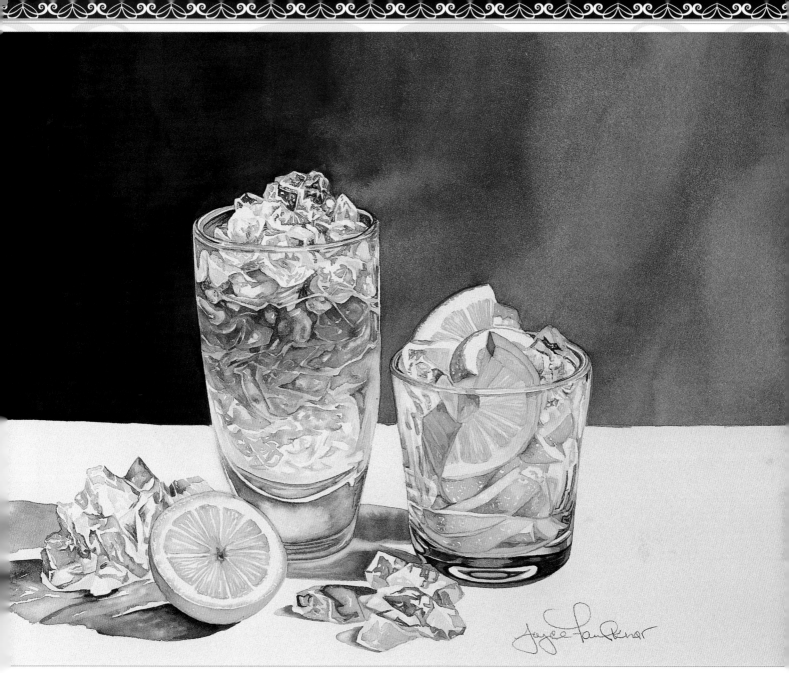

11 PAINT THE SHADOWS TO FINISH

Use the wet-into-wet technique, the blue-gray mixture and the 1½-inch (38mm) one-stroke to add the shadows. Once the shadows are painted in, stand back to view the fully anchored painting. Evaluate the ice cubes on the tabletop. Anywhere you see a hint of shadow within the lightest values, you probably need additional glazing. Glazing the ice cubes is a delicate process. Once the painting is bone dry, use your ¼-inch (6mm) flat to glaze those lighter values and all the highlights using just a hint of the gray-blue mixture.

SHADOW TECHNIQUES

Wet-into-wet works best for shadows of glass and other transparent objects.

Blue Vase With Distortion

This is a typical vase from your local florist until you place it in a still life and begin to explore the beautiful blues and distortions that appear from the stems. This demonstration is all about the stems intertwining within the blue vase and the distortions that the water creates.

SUPPLIES

~SURFACE~
140-lb. (300gsm) cold-pressed paper

~BRUSHES~
No. 6 round
¼-inch (6mm) flat
½-inch (12mm) one-stroke
1-inch (25mm) one-stroke
1½-inch (38mm) one-stroke

~PIGMENTS~
Burnt Sienna
Green Gold
Permanent Alizarin Crimson
Permanent Rose
Phthalo Turquoise
New Gamboge
Winsor Green (Blue Shade)
Winsor Orange (Red Shade)

~OTHER~
HB pencil
Transfer paper

Detailed Drawing
When transferring any drawing, be sure to add all the information you can. For instance, if the value changes within the petal stems or glass, indicate these shapes in your drawing. This will help you remember where you need to adjust your pigments.

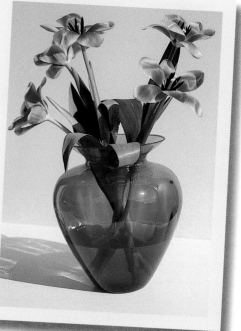

Reference Photo

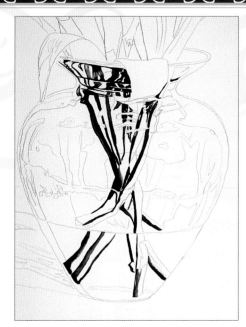

1 ORGANIZE YOUR DARK VALUES

Using a no. 6 round and Winsor Green (Blue Shade) mixed with a hint of Alizarin Crimson, paint the darkest values of the stems, beginning with the middle of the vase. Find, enhance and exaggerate the distorted shapes within the entanglement of the stems—have some fun. You can do a lot with the shapes within the vase and they will still be believable to the viewer.

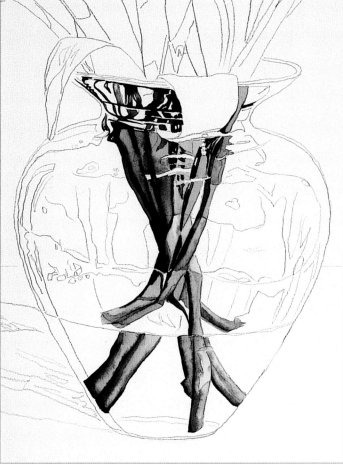

2 PAINT THE MIDDLE VALUES OF THE STEMS

Once all the darkest shapes are in place, complete the stems with medium-to-light values. Use your ¼-inch (6mm) flat, and tints of Green Gold with a hint of Burnt Sienna for the lightest portions. Glaze over the already existing dark values with this mixture to soften the hard edges.

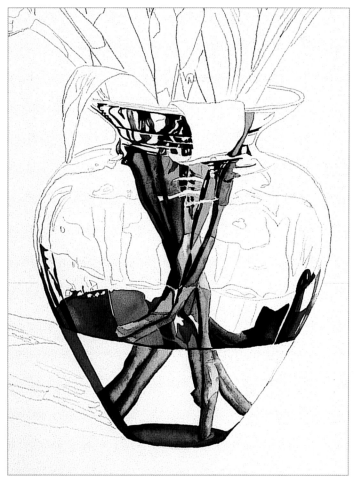

3 PAINT THE LARGEST, DARKEST SHAPES OF THE VASE

Using the ½-inch (12mm) one-stroke and Phthalo Turquoise with a hint of Winsor Green (Blue Shade), add the largest shapes. Think of this phase of the painting as building your foundation. Preparation is everything for painting dark to light.

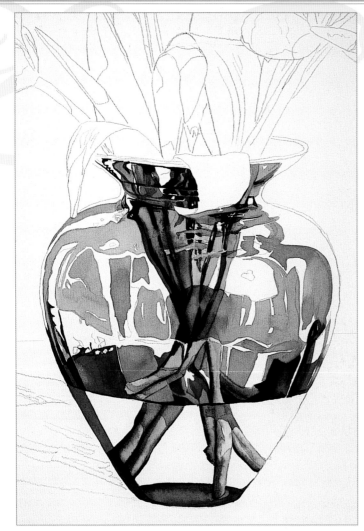

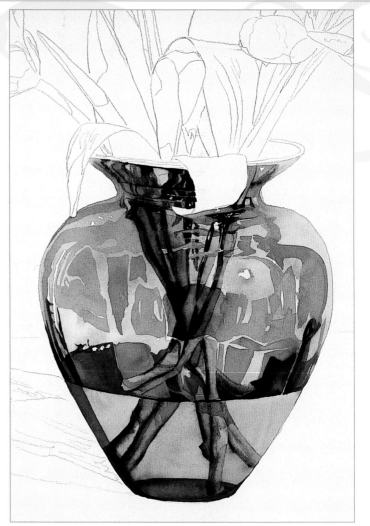

4 GLAZE IN THE MIDDLE VALUES OF THE VASE
Use tints of Phthalo Turquoise and a ¼-inch (6mm) flat to add the middle values. Use a light touch with a fully loaded brush to keep the dark pigments from bleeding too much.

5 FINISH GLAZING THE VASE
Using a 1½-inch (38mm) one-stroke, mix a very light wash of Phthalo Turquoise (90 percent water and 10 percent pigment). Glaze the vase with a light touch. This will add the final gloss to the glass.

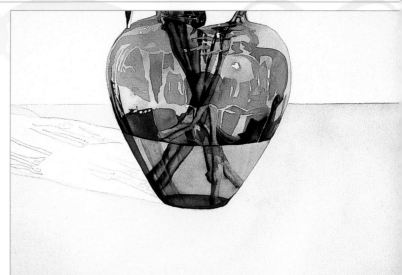

6 PAINT THE RIM OF THE VASE
The rim of the glass has a dark blue outline. Use the no. 6 round, and a dark mixture of Phthlalo Turquoise with a hint of Winsor Green (Blue Shade) to paint that line as a lost-and-found edge as the rim turns. This will give the rim a transparent edge.

7 PAINT THE TABLETOP WET-INTO-WET
Make a blue-gray wash using Permanent Alizarin Crimson, a hint of Winsor Green (Blue Shade) and Phthalo Turquoise. Lay water onto the tabletop using the ½-inch one-stroke (12mm), then paint in the premixed blue-gray.

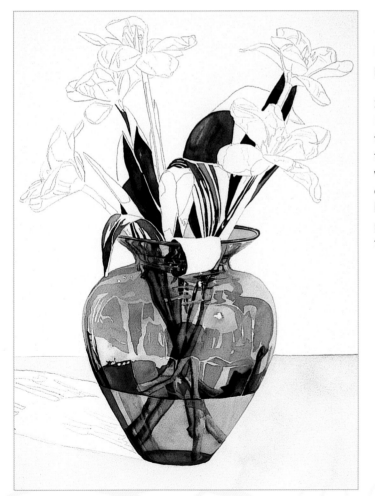

8 PAINT THE LEAVES AND STEMS OUTSIDE THE VASE
Keeping with the dark-to-light theme, paint the darkest shapes using a ¼-inch (6mm) flat and Winsor Green (Blue Shade), a hint of Alizarin Crimson and Phthalo Turquoise. Remember, this is the foundation work for the glazing of the medium and light values. Starting with the darkest values will help you create the next value by just adding a little water to the mixture. Repeating the process is an easy way to gradually get to the lightest value within that hue.

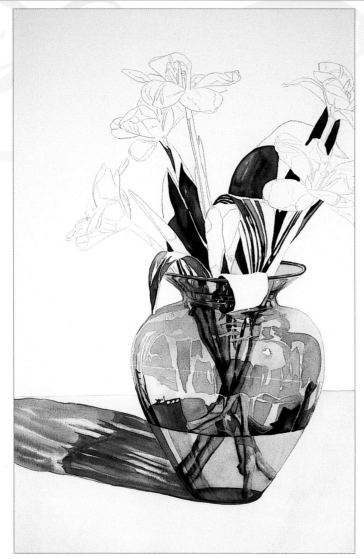

9 ADD THE SHADOW

While you still have the dark shape mixture from step 8 on your palette, lay in the shadow. Using the wet-into-wet technique and a ½-inch (12mm) one-stroke, wet the surface of the shadow with a light wash of the mixture. While the shadow is still damp, add a heavier mixture of Phthalo Turquoise for the darker areas.

10 GLAZE THE STEMS AND THE LEAVES

Using the ¼-inch (6mm) flat, a mixture of Green Gold and Burnt Sienna, and a light touch, glaze the stems. Be sure that your brush is fully loaded with pigment to give you even flow. Switch to a the 1-inch (25mm) or 1½-inch (38mm) one-stroke for the leaves (depending on the size you want them to be). Fewer strokes is better when glazing.

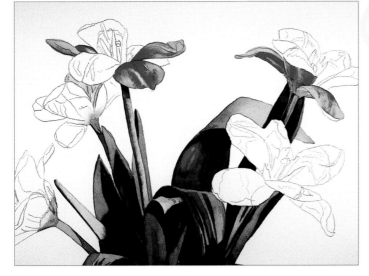

11 PAINT THE TULIPS

When I photographed this still life, the light was perfect but the tulips were not. I gave them a little bit of help by turning the petals outward. The complementary colors will add a great impact to this otherwise cool still life.

Use the wet-into-wet technique to apply New Gamboge to the yellow portion of the petals with a no. 6 round. While the petals are still damp, add a Winsor Orange (Red Shade) and Alizarin Crimson mixture. Paint in the direction in which the petals grow. This will give you wonderful, soft edges from the orange-red to the yellow.

12 FINISH

Repeat the process in step 11 for each petal. Add the middle stems using the no. 6 round and a dark gray made with Winsor Green (Blue Shade) and Permanent Alizarin Crimson.

Beveled Orange Juice Squeezer

When looking at the reference photo, check out the center where you can see the orange through the glass and the wonderful distortion that runs with the swirls. When transferring this piece, trust what you see and draw in all the smaller shapes within shapes. The dark and light shapes will help this piece become as transparent as the reference photo. The more information you draw in, the better off you will be during the painting process.

There is a point within this painting when you will paint the essence of the curves and the lights and darks of the glass; don't try to represent each shape exactly as you see it in the reference photo. The photo is a guide, not an absolute. Now sit back and observe: You will see the transparency of the glass become apparent.

SUPPLIES

~SURFACE~
140 lb. (300gsm) cold-pressed paper

~BRUSHES~
No. 6 round
¼-inch (6mm) flat
½-inch (12mm) one-stroke
1½-inch (38mm) one-stroke

~PIGMENTS~
New Gamboge
Permanent Alizarin Crimson
Quinacridone Gold
Winsor Blue (Red Shade)
Winsor Green (Blue Shade)
Winsor Orange (Red Shade)

~OTHER~
HB pencil
Eraser

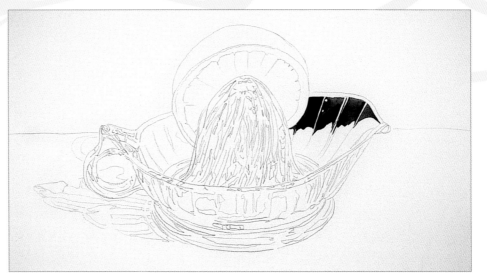

1 LOCATE THE DARKEST VALUES
The largest darkest shapes are in the back side of the squeezer. Mix Winsor Blue (Red Shade), Quinacridone Gold and Permanent Alizarin Crimson for this darkest value and paint those shapes with your ½-inch (12mm) one-stroke.

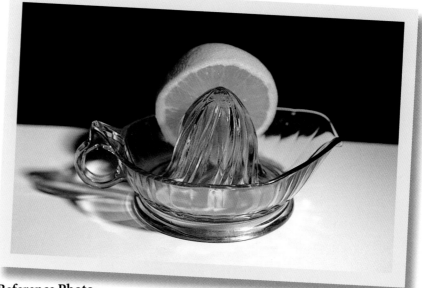

Reference Photo
I picked up this piece at the local antique store. I had my eye on it for months, but I didn't buy it right away because thought I might come across something better. But as I continued to search, I knew this was the one. Its center is nice and high so that it is really visible; the handle and spout are added bonuses.

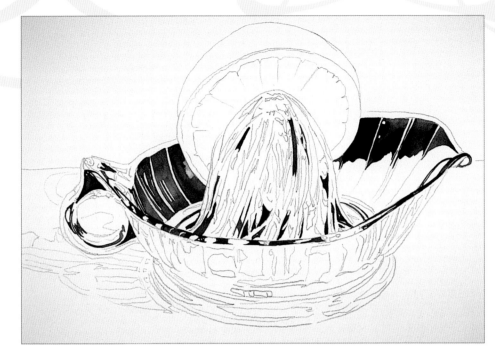

2 PAINT THE RIM, HANDLE AND CENTER

Take one portion at a time. Use the same colors you did for step 1 and begin with the rim, using a ¼-inch (6mm) flat to match the shapes on the rim. Make some of the shapes wider and some more narrow. For the handle, follow the curves and paint what you see. There are only a few dark shapes in the center, mostly next to the orange.

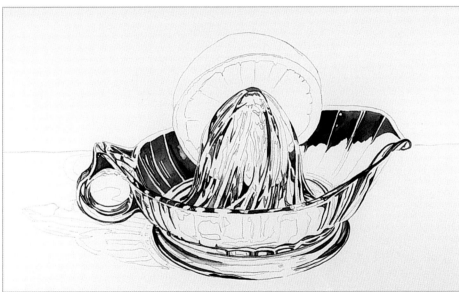

3 FINISH THE DARK VALUES AND ADD SOME MEDIUM DARKS

There are two stripes coming from each side of the base, stopping just before the center. Switch to the no. 6 round as you paint the curvy shape and complete the darkest values. Just capture the obvious shape; it's best not to overwork them at this point.

Mix Quinacridone Gold and Winsor Blue (Red Shade) for the medium-dark greens. Use your ¼-inch (6mm) flat to add the shapes. Be sure to include the medium-dark value changes within. Paint the front part of the glass up to the handle. Follow the curves as you paint toward the center. Paint only the medium to dark values.

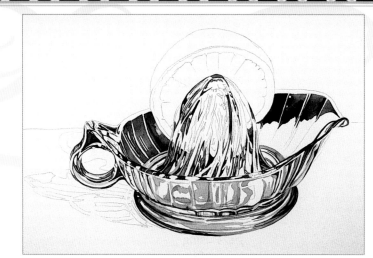

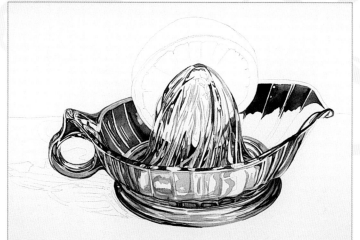

4 ADD THE MEDIUM LIGHT VALUES WITH A YELLOW HUE

The glass color changes throughout this piece—from a deep rich green to a medium-value green with a blue hue, then to a yellow-green. To get the yellow-green medium light value, just add a little more Winsor Green (Blue Shade) and Quinacridone Gold to your existing mixture. Paint the center up to the bottom of the orange, around the rim, into the glass, onto the protruding orange juice squeezer area and to the handle.

5 PAINT THE MEDIUM LIGHT VALUES

Add water to your puddle of pigment to get the next lightest values. These show up next to the medium darks in the photo. With your ¼-inch (6mm) flat, lay in the medium light values starting with the front of the glass, working to the handle, then to the center. Follow the curves of the glass. Keep your brush wet to keep the flow of the strokes looking clean and transparent.

6 PAINT THE DISTORTED SECTION OF THE ORANGE

Mix Winsor Orange and New Gamboge. Using your no. 6 round, paint in the orange shapes in the center.

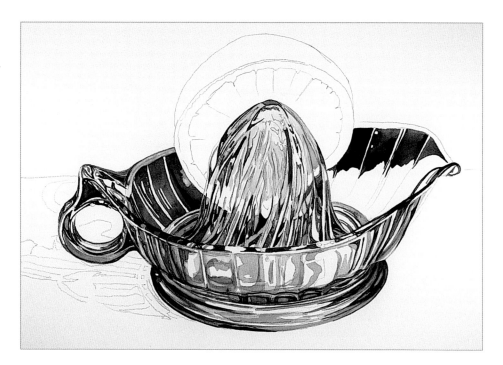

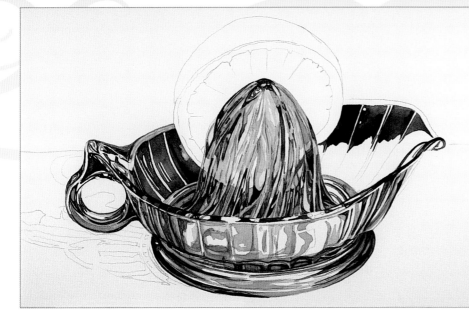

7 FINISH THE CENTER

Add a hint of New Gamboge to the rind that you can see through the glass in the center of the squeezer. Now glaze over the distorted orange shapes. Allow the painting to dry thoroughly and erase any pencil marks. Then add lots of water to the Winsor Green (Blue Shade) and Quinacridone Gold mixture for a light glaze using your ½-inch (12mm) one-stroke. Be selective, though. There will be areas where no glazing is needed.

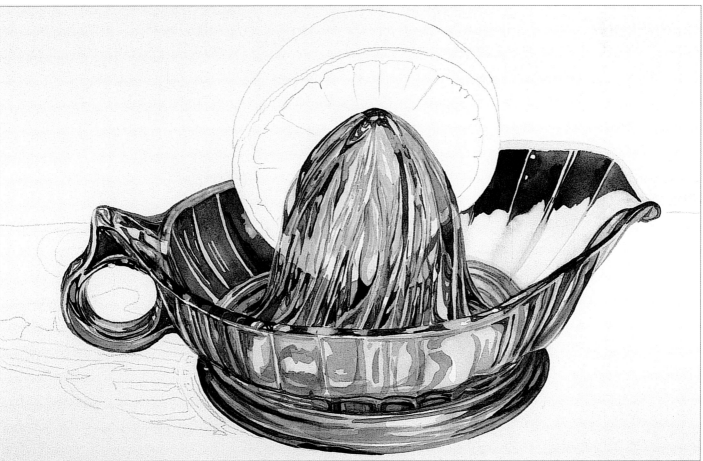

8 GLAZE THE REMAINDER OF THE SQUEEZER

Using a ½-inch (12mm) one-stroke, add lots of water to the Winsor Green (Blue Shade) and Quinacridone Gold mixture for a light glaze. Apply the glaze gently with a light touch and a very moist brush. This will keep the previous layers of pigment from moving.

9 BEGIN THE ORANGE RIND

Mix Winsor Orange and Quinacridone Gold for the darkest side of the rind. As you move to the top of the orange, switch to pure Winsor Orange (Red Shade), using your no. 6 round.

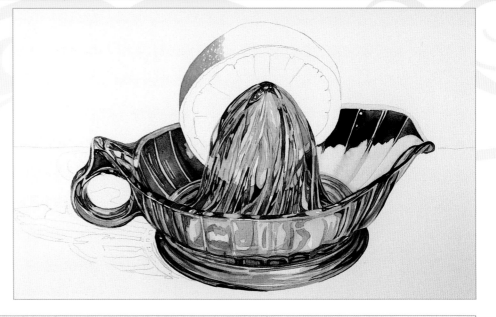

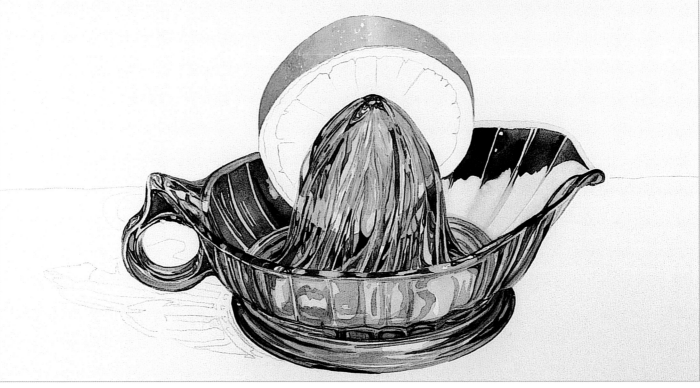

10 COMPLETE THE RIND

Still using the no. 6 round, as you reach the highest point of the rind, switch to New Gamboge. This is the lightest, brightest section of the rind. Gradually switch back to Winsor Orange (Red Shade) until the rind slowly turns.

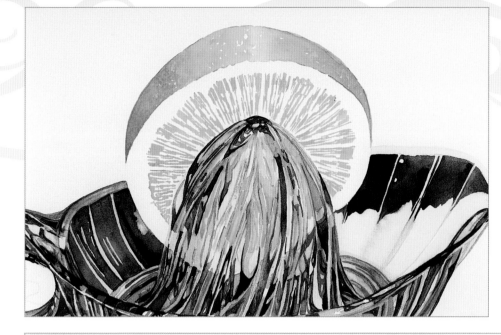

11 BEGIN THE ORANGE PULP

Leave the white of the paper for the vein area. You'll glaze that after you paint the pulp. With your ¼-inch (6mm) flat, mix Winsor Orange (Red Shade) and New Gamboge. Pay attention to the direction of the pulp; it's like little pie shapes.

12 GLAZE THE PULP

Glaze each section with Winsor Orange (Red Shade) and New Gamboge. The glaze should be 95 percent water.

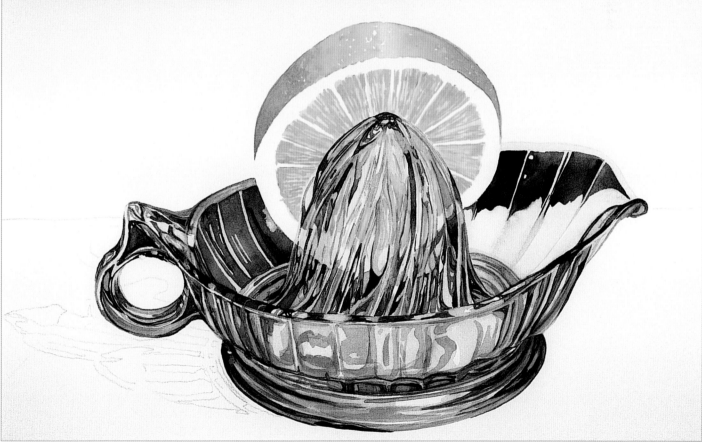

13 PAINT THE RIM OF THE ORANGE

Glaze the rim with New Gamboge. While the paint is still wet, paint the edge with Winsor Orange (Red Shade); it should bleed slightly into the yellow. Lastly, paint the vein with the New Gamboge glaze.

14 PAINT THE BACKGROUND

The combination of pigments you'll need is the same you used for the darkest values you painted at the beginning of the painting: Winsor Blue (Red Shade), Quinacridone Gold and Permanent Alizarin Crimson. Use a 1½-inch (38mm) one-stroke and the wet-into-wet technique to achieve a dark background with rich subtle changes.

Allow the pigment from your loaded brush to flow evenly onto the saturated paper. Use the brush to manipulate the pigment, but do not go back over the pigment once it's on the paper. Just allow the water to work its magic.

TRUST YOURSELF

Stand back and look at the painting as a whole. Observe the value contrast. Ask yourself: Is the value contrast strong enough? Can I add any more darks to pop out the lights? Are there any places where I can glaze?

15 PAINT THE SHADOW TO FINISH

Using the wet-into-wet technique, the pigment you mixed for the background and your no. 6 round, gently lay in the pigment. Use as few strokes as possible for this part of the painting. Allow the pigment to float into place. Once the shadow is bone dry, glaze over where you see green in the shadow with Winsor Green (Blue Shade).

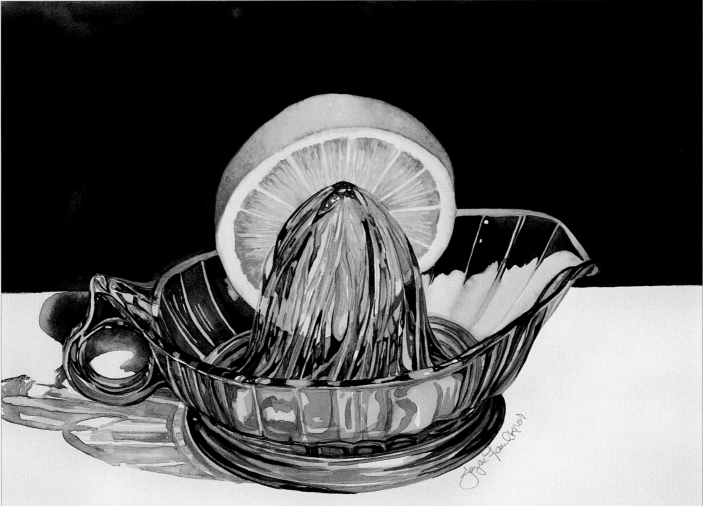

HOW TO FINISH A PAINTING

When you have finished a painting, it is best to live with it for a few days. Set it in a place in your studio or home where you frequently pass by, and there will be a time when the painting will speak to you, meaning you will see what, if anything, you may add to the painting.

Beveled Vase With Distorted Shapes

Adding an organic subject always brings "life" to a still life. Finding manmade objects that reflect nature is always a plus. I love this piece of glass and the fun distorted shapes of the onions and garlic that run through its beveled edges.

SUPPLIES

~SURFACE~
140-lb. (300gsm) cold-pressed paper

~BRUSHES~
No. 6 round
¼-inch (6mm) flat
½-inch (12mm) one-stroke
2-inch (51mm) one-stroke

~PIGMENTS~
Burnt Sienna
Permanent Alizarin Crimson
Phthalo Turquoise
Quinacridone Gold
Winsor Green (Blue Shade)

~OTHER~
HB pencil
Eraser

1 PAINT THE LARGEST AND DARKEST MEDIUM GRAY VALUES
As you can see from the reference photo, the glass appears to have curved stripes. The majority of the dark shapes appear at the base.

Mix two puddles of pigment, one to represent the black shapes and another, a few shades lighter, to represent the teal shapes. For both use Winsor Green (Blue Shade) and Permanent Alizarin Crimson with a hint of Phthalo Turquoise.

Use a ¼-inch (6mm) flat to gently paint in the black shapes that are the edges of the beveled portions. While this area is still wet, clean your brush and lay in the teal pigment next to the dark shapes. The two should slowly bleed together. Think one shape at a time.

Reference Photo
This vase is special to me. It was a gift from my watercolor class. But I didn't only select this piece for sentimental reasons; I was also struck by the curves of the vase that went along with the curves of the onions and garlic.

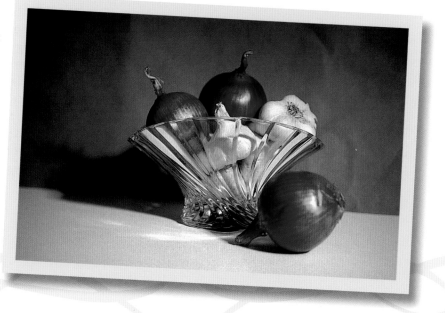

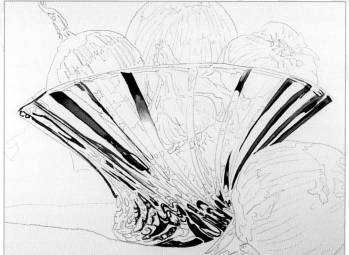

2 PAINT THE VASE'S BASE

Add the swirls and shapes within the shape of the vase's base using your no. 6 round and a puddle of the Winsor Green (Blue Shade) and Permanent Alizarin Crimson mixture. Within the dark shapes you will see highlights separating the tight swirls. It is important to keep these highlights; they will help you establish the shape of the base. As you can see from the reference photo, the darkest shapes appear on the right side. But you will have a few dark shapes on the left side that will reach up to the top.

3 BEGIN THE DISTORTED ONION SHAPES WITHIN THE BEVELED EDGES

Separating the beveled edges from the flat glass section of the vase will help you get this portion of the painting organized and keep you from getting lost. Concentrate on one task at a time.

Mix Permanent Alizarin Crimson and a hint of Phthalo Turquoise for the onion color. Begin with the large dark shape on the beveled edge. Look for a starting point and a stopping point within the shape. Use the no. 6 round to paint in a nice juicy shape at the top of the edge, pulling the pigment with your brush. Rinse the brush and begin where you left off to lighten the pigment.

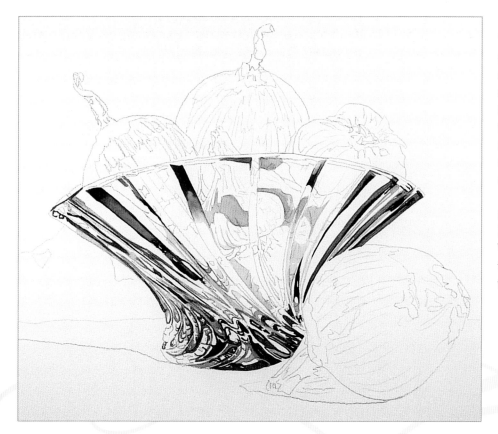

4 ADD THE GRAY VALUES

Once you have placed the dark shapes representing the onion, you can begin adding the lighter-valued onion shapes. Add Winsor Green (Blue Shade) to your puddle from step 3 to turn the mixture gray. Add the gray shapes that begin to develop the vase, using your no. 6 round. Follow the swirl of the beveled edge.

The left side of the vase has a vast array of lines that look as though they blend together as they swirl to the top. When painting this area, leave a little of the white of the paper to give the lines the separation they need.

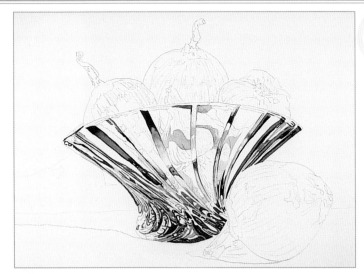

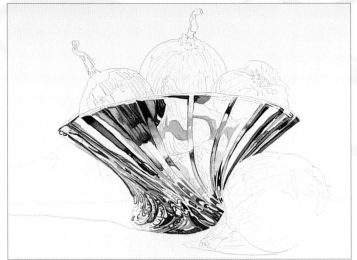

5 PAINT THE DISTORTED GARLIC SHAPES IN THE BEVELED EDGES

Mix a hint of Burnt Sienna into Quinacridone Gold and paint the distorted shapes of the garlic on the beveled edges. Some of the darkest shapes are almost brown in color; add a hint of Winsor Green (Blue Shade) to the puddle for those spots (you should get a beautiful, rich brown). Some of the shapes begin with a very dark value of brown and then change to a lighter shade of gold. For those, add water and pull the pigment down to create the lighter shape.

6 PAINT THE ONION BETWEEN THE BEVELED EDGES

Premix three values of the Permanent Alizarin Crimson and a hint of Phthalo Turquoise to get ready for the next few steps. The distortion is not so prominent in these spots, but it is still there. You'll keep working on the onion shapes.

With your ¼-inch (6mm) flat, paint in the darkest values. Let the paint dry completely.

Then, using the lightest puddle of pigment, glaze using your ½-inch (12mm) one-stroke. As you are glazing, add the middle value while the glaze is still wet. Adding this value creates the illusion of depth and transparency in the glass.

7 BEGIN THE GARLIC

Using your mixture of Quinacridone Gold and a hint of Burnt Sienna, begin painting the darkest shape of the garlic. Because it's so light, you will need to lay in the dark shapes, rinse the brush, then lighten the pigment, following the curves of the garlic. Just paint the shapes and the values as you see them.

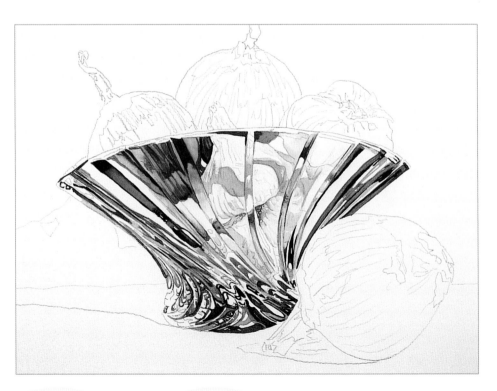

Apply glazing

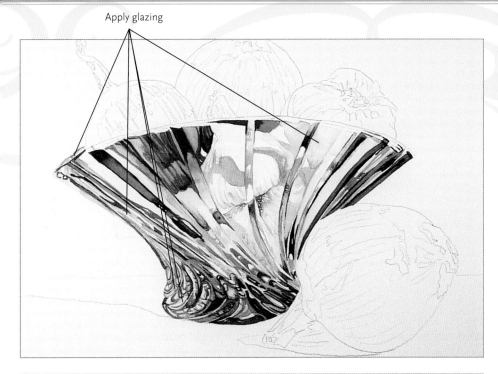

8 GLAZE THE GLASS AND SHADOWS

With your ½-inch (12mm) one-stroke, glaze some of the lightest shapes of the vase using Winsor Green (Blue Shade) and Phthalo Turquoise, mixed with 95 percent water. This glaze is very, very light. The shapes just need a slight amount of color.

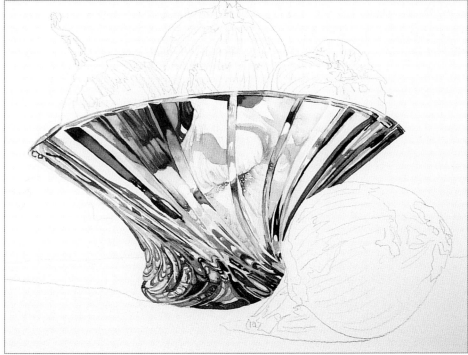

9 DETAIL THE EDGE OF THE VASE

The rim of the vase has lost-and-found lines and edges. Using the mixtures you used for the onion, the garlic and the glaze, and your no. 6 round, paint in the lines and edges as you see them in the reference photo.

SAVE ADJUSTMENTS FOR LATER

Now that the glass piece is finished, you may be tempted to work on adjusting some values or glazing over some areas. It is best if you wait and finish the background, shadows, onions and garlic. Finishing the rest of the painting will give you more information, and you may or may not want to add those details.

10 PAINT THE OUTSIDE ONIONS' DARKEST VALUES

Using the dark-to-light method on the onions will help define their shapes and textures. Mix Alizarin Crimson with a hint of Phthalo Turquoise. Using the no. 6 round, follow the curves of the onions as you paint in the darkest values.

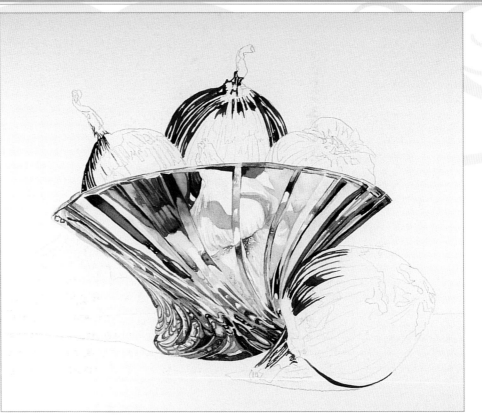

11 PAINT THE ONIONS' MEDIUM VALUES

Add water to the pigment you mixed in step 10 to create your medium values. Using the no. 6 round, paint in the shapes.

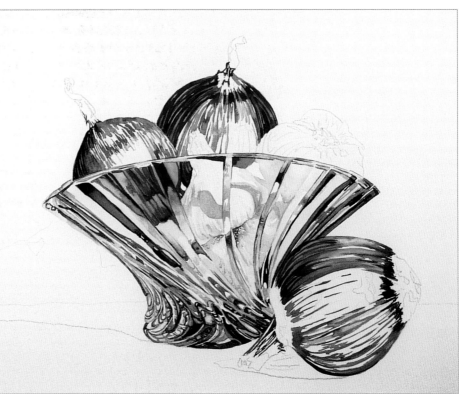

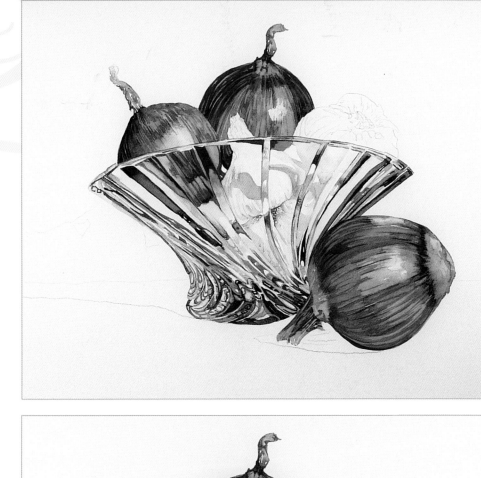

12 ADD THE STEMS AND GLAZE THE ONIONS

For the stems, add Quinacridone Gold to the medium value mixture. Then add water and more Quinacridone Gold. The final glaze should have a hint of gold showing.

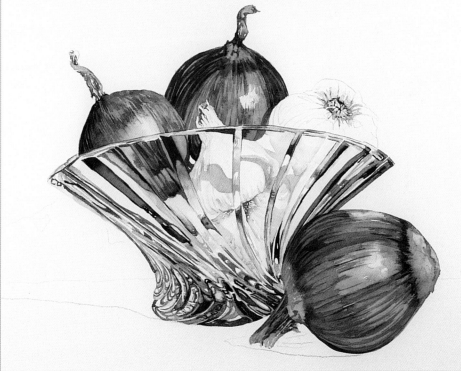

13 BEGIN THE ROOT OF THE GARLIC

The root of the garlic is where you will find the darkest values. Mix Burnt Sienna and Winsor Green (Blue Shade) for a rich brown. Using the no. 6 round, paint the dark shapes as you see them, creating the circle image at the base of the garlic. Let it dry completely.

14 BEGIN THE GARLIC'S MEDIUM VALUES

With a medium-value Burnt Sienna and Quinacridone Gold, paint the shapes following the contour of the garlic.

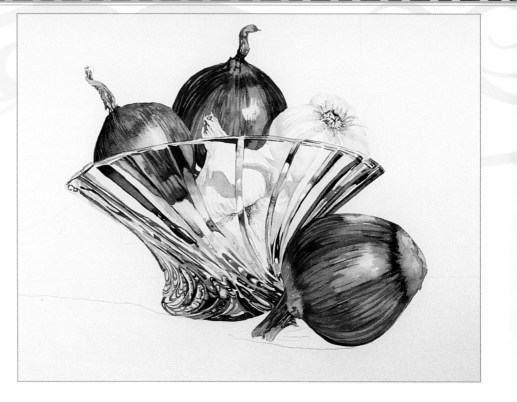

15 ADD COOL VALUES TO THE REST OF THE GARLIC

The rest of the garlic needs more of a cool value. Still using the no. 6 round, add a hint of Phthalo Turquoise to the medium value, then add water to lighten the mixture even further. Follow the contour of the garlic and soften the edges. Allow this to dry.

Erase any remaining pencil lines. The garlic may look a bit unfinished, needing more details to make it "pop." But it's best to wait until you finish the background before making further adjustments.

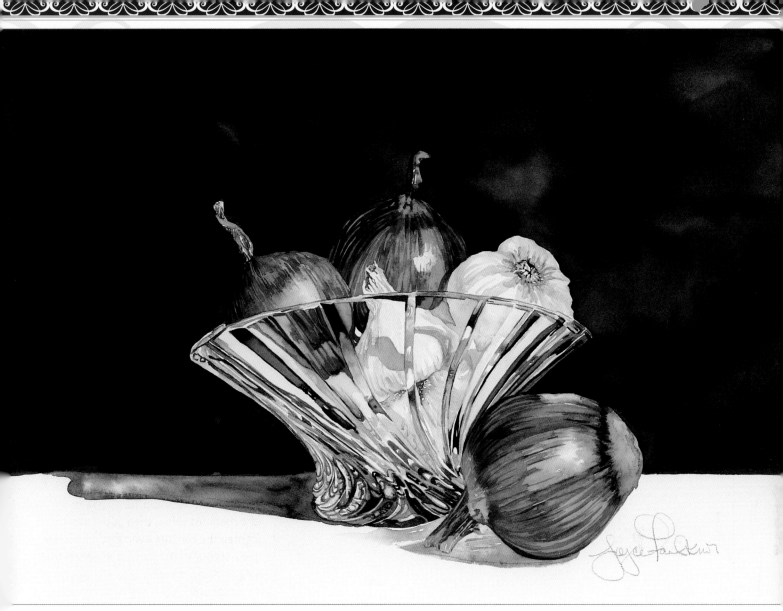

16 PAINT THE BACKGROUND TO FINISH

Mix Burnt Sienna and Phthalo Turquoise. Use the wet-on-dry technique and a 2-inch (51mm) one-stroke for large washes and a no. 6 round for the small areas.

Twist the one-stroke brush to get the texture for the background. Begin on the dark side and add small amounts of water as you move to the lighter side.

Once the background is bone dry, paint the shadows. The background shadow is the same mixture of pigment. The tabletop background has a bit more gray in it, so add Permanent Alizarin Crimson for that, and add water so the shadow is a little lighter in value. Add more Permanent Alizarin Crimson to get an even grayer shade for the shadow under the onion.

Shapes Create a Complex Background

As you are painting the glass with ripples, you will begin to notice the shapes. These abstract shapes together create a beautiful, realistic form. Focus on the largest darkest shapes first to organize the process.

SUPPLIES

∼SURFACE∼
140-lb. (300gsm) cold-pressed paper

∼BRUSHES∼
No. 6 round
¼-inch (6mm) flat
½-inch (12mm) one-stroke
1½-inch (38mm) one-stroke

∼PIGMENTS∼
Burnt Sienna
Permanent Alizarin Crimson
Phthalo Turquoise
Winsor Blue (Red Shade)
Winsor Green (Blue Shade)

∼OTHER∼
HB pencil
Eraser
Transfer paper

1 MAKE A DETAILED DRAWING
Be sure to include all shapes and value changes as you transfer your drawing. Double check it before removing your colored copy. The more information you include in the drawing, the easier the painting process will be.

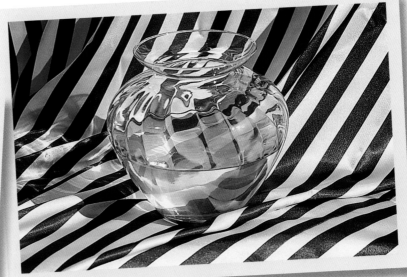

Reference Photo

2 PAINT THE DARKEST VALUE

Mix the darkest value using Permanent Alizarin Crimson, Winsor Green (Blue Shade) and a small amount of Winsor Blue (Red Shade). The pigment should be a rich, dark gray (almost black), and the puddle should be a creamy consistency, very moist and not thick. Locate the biggest, darkest value within the vase. Using your ¼-inch (6mm) flat, paint each section separately, leaving a hint of white showing where the ripples of the glass begin and end. Keep your brush loaded with the pigment. The dark distorted shapes are the striped tablecloth. Have some fun while painting these shapes, and remember to follow the pattern of the glass.

Hard edges

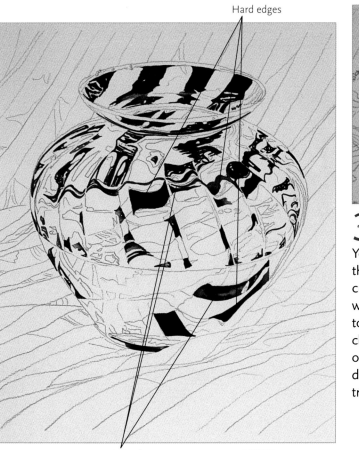

Soft edges

3 COMPLETE THE DARKS USING HARD AND SOFT EDGES

Your darkest values will have some lighter shapes within them, some with soft edges and some with hard edges. To create the soft-edged value changes, clean your brush, and with the dampened brush pull the edge of the dark pigment to create a lighter shade of gray. For the hard-edged value changes, paint around the lighter values and glaze in later once the paper is dry. Having an assortment of different dark values within the darkest shapes will create light and transparency.

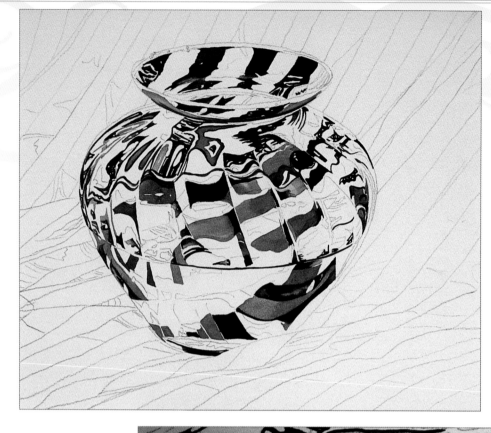

4 PAINT THE MEDIUM VALUES

Once all the darkest values are in place, add a bit more water to your pigment to get a medium value. Premix several puddles from a medium dark to a medium light.

Note that the water rim is a lost-and-found line. It's dark on the right and gets lighter as it moves to the left of the glass. Leave the white of the paper for the lightest values and the highlights.

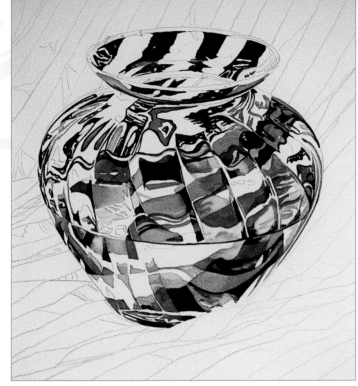

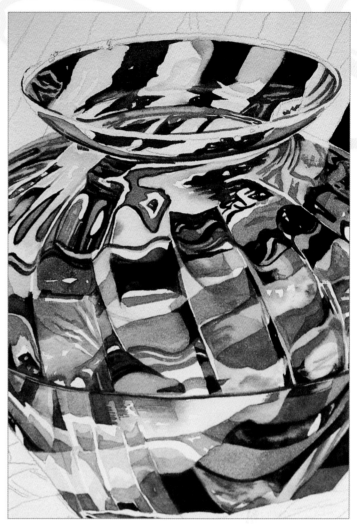

5 PAINT THE LIGHTEST VALUES

Begin with the largest shapes to paint in the lightest values. Remember that the ripples of the glass are indicated by their surrounding shapes. As you are laying in the light values, you may find that dropping in a little pigment while the wash is still wet will help illuminate the shapes where there are both lights and darks within the shapes.

6 GLAZE THE LIGHTS WITHIN THE DARKS

Using your 1½-inch (38mm) one-stroke, glaze a wash of green-gray (Permanent Alizarin Crimson, Winsor Green [Blue Shade] and Phthalo Turquoise) over the dark areas that have the white of the paper that you left for the lighter values. Be sure to follow the shape of the glass.

7 ACCENT THE HIGHLIGHTS

Allow the painting to dry completely and erase any stray pencil marks. With the no. 6 round, apply the dark value you used in step 4 around the lightest parts of the highlights. The darker value next to the highlight will create a much-needed contrast.

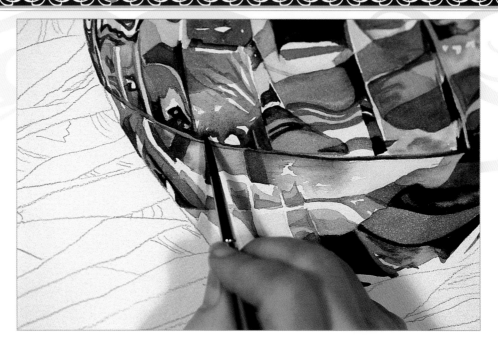

8 BEGIN THE TOP RIM OF THE VASE

Light bounces through the rim, so use a variety of values based on the mixtures you've created on your palette already. Follow the stripes you have filled in so far. And leave the back part of the rim until after you have painted the background. Stick with your no. 6 round for now.

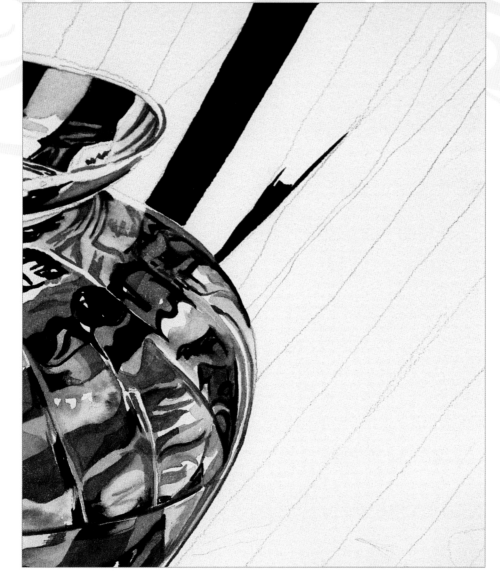

9 BEGIN THE BACKGROUND

Mix Alizarin Crimson, Winsor Green (Blue Shade) and Burnt Sienna to create a beautifully deep, rich black. Fully-load your ½-inch (12mm) one-stroke and make sure the pigment is not too thick before you begin laying in the background. You want just enough water so that the paint flows smoothly.

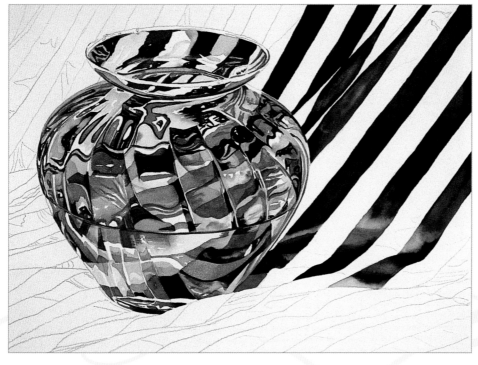

10 APPLY LIGHT AND DARK VALUES TO THE STRIPES

You want to re-create the change of values within the stripes, which will create movement and flow to the drapery. To do this, mix a separate puddle of the dark pigment you've been using for the stripes. Then rinse your ½-inch (12mm) one-stroke, leaving some water on it. Remix it into the pigment to get a lighter value, then slowly continue the stripe from dark to light. Repeat the rinsing and remixing process every time you want to lighten the value a little.

11 PAINT THE SHADOWS

Lay down a medium-to-dark pass of your gray mixture at the darkest part of the fold, then clean your brush. With your damp no. 6 round, gently pull the pigment in the direction of the fold. This will create shadows on the drapery.

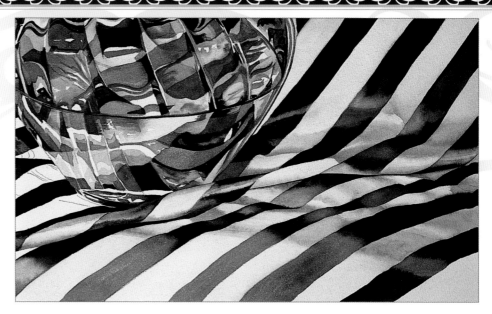

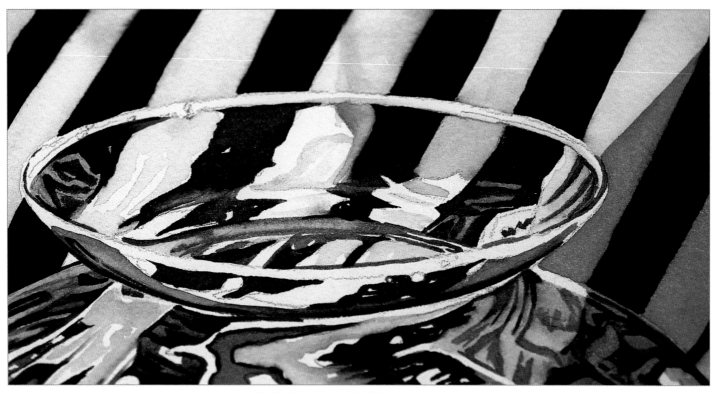

12 COMPLETE THE RIM

Once you have finished the background, you can complete the rim (the mouth of the vase). Load up your no. 6 round with the darkest stripe value, (making sure you have a nice tip) and begin the edge of the rim. Rinse your brush, then reload it, keeping a little water on the tip, and continue along the rim. This will give you a nice lost-and-found line.

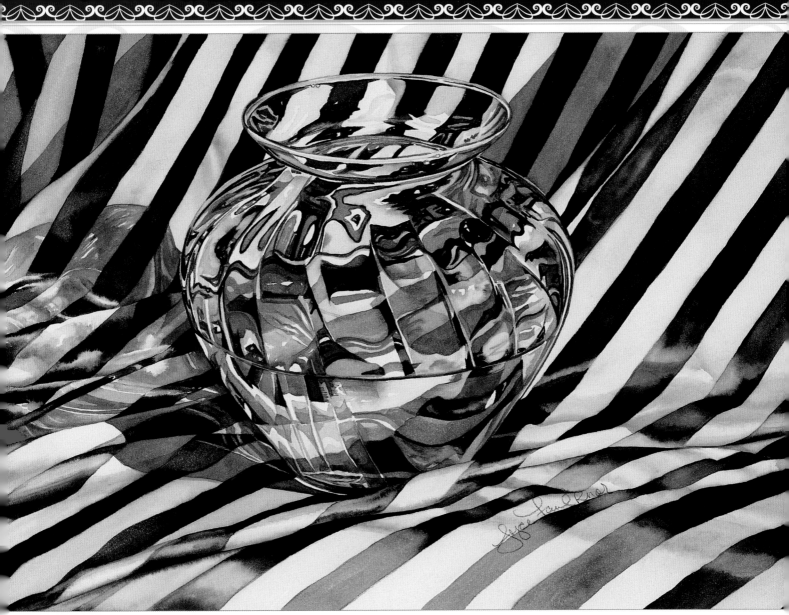

13 CHECK FOR DETAILS TO FINISH
Stand back from the painting and check your range of values. If you see that the dark values are not dark enough, now is the time to lay in even darker ones.

Detail Work: Depression Glass

The designs in depression glass are incorporated into the actual glass. This challenging detail work will come at the beginning of the piece. Notice all the intricate shapes; many of these shapes are the darkest values of the piece. Once you have these in place, the rest will be mostly glazing in the medium-to-light values.

SUPPLIES

∼SURFACE∼
140-lb. (300gsm) cold-pressed paper

∼BRUSHES∼
No. 6 round
½-inch (12mm) one-stroke

∼PIGMENTS∼
Burnt Sienna
Permanent Alizarin Crimson
Quinacridone Gold
Winsor Blue (Red Shade)
Winsor Green

∼OTHER∼
HB pencil

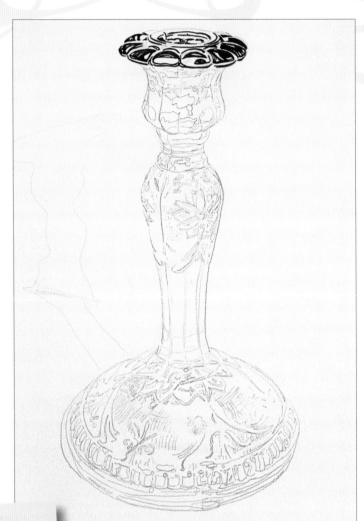

1 BEGIN THE DETAILS
Mix Burnt Sienna and Winsor Blue (Red Shade) to get a rich, dark brown. Using your no. 6 round and a very moist puddle of pigment, roll your brush into a fine tip and paint in the details, beginning with the top of the candlestick. This is the majority of the work, so trust the shapes you see. Painting what you see will help you complete a successful painting.

Reference Photo

2 WORK THE MIDDLE DETAILS
Systematically work your way down the candlestick, keeping the shapes organized. Do not jump around; just paint each section as you come to it.

3 WORK THE BASE DETAILS
The base has the most detail. Still using your no. 6 round and the mixture you created in step 1, outline the darkest values of the design, the raised edges. It's a lot of work, but the finished piece will be well worth it.

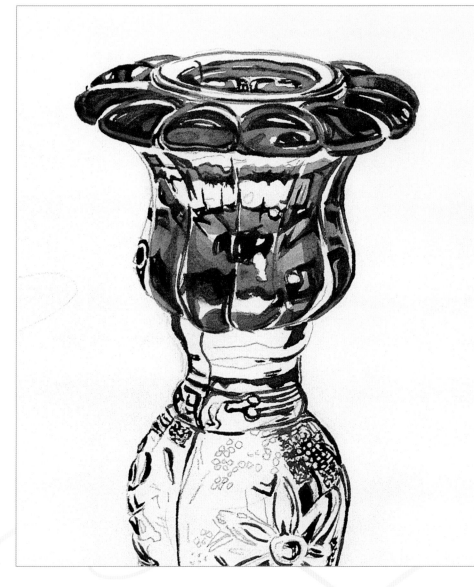

4 GLAZE IN MEDIUM-TO-DARK VALUES IN THE TOP PORTION
Make sure your first pass is bone dry. Mix Quinacridone Gold, Burnt Sienna and a hint of Winsor Blue (Red Shade), then glaze in each section using your ½-inch (12mm) one-stroke brush. Use a very light touch with not too many brush strokes to prevent the dark values from moving too much.

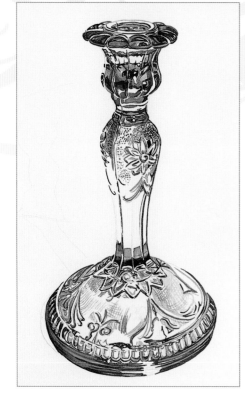

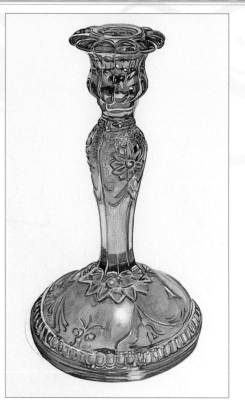

5 ADD MEDIUM-VALUE DETAILS

Mix a hint of Burnt Sienna into some Quinacridone Gold, then paint in the medium-value details using the no. 6 round in the middle and base of the candlestick.

6 GLAZE THE MIDDLE AND BASE

Once your painting is dry, glaze it using your ½-inch (12mm) one-stroke with a medium to light wash using the mixture from step 5. Be sure to leave the white of the paper for the highlights.

7 GLAZE IN THE LIGHTEST VALUE

Lighten the Quinacridone Gold and a hint of Burnt Sienna even more and glaze it in using your ½-inch (12mm) one-stroke. Be sure this mixture is the lightest value of all. Apply it using a gentle touch. The paint should float out of the brush without much pressure.

8 ADD THE SHADOW TO FINISH

Mix Winsor Green and Permanent Alizarin Crimson to produce the gray shadow. Use the wet-into-wet technique and your ½-inch (12mm) one-stroke to drop in the gray pigment. Let the pigment float onto the shadow shape.

Once you've painted in the shadow and your painting is completely dry, step away and observe your value changes. Ask yourself if you need to add any more to enhance the dark values. Make any finishing touches and your painting is complete!

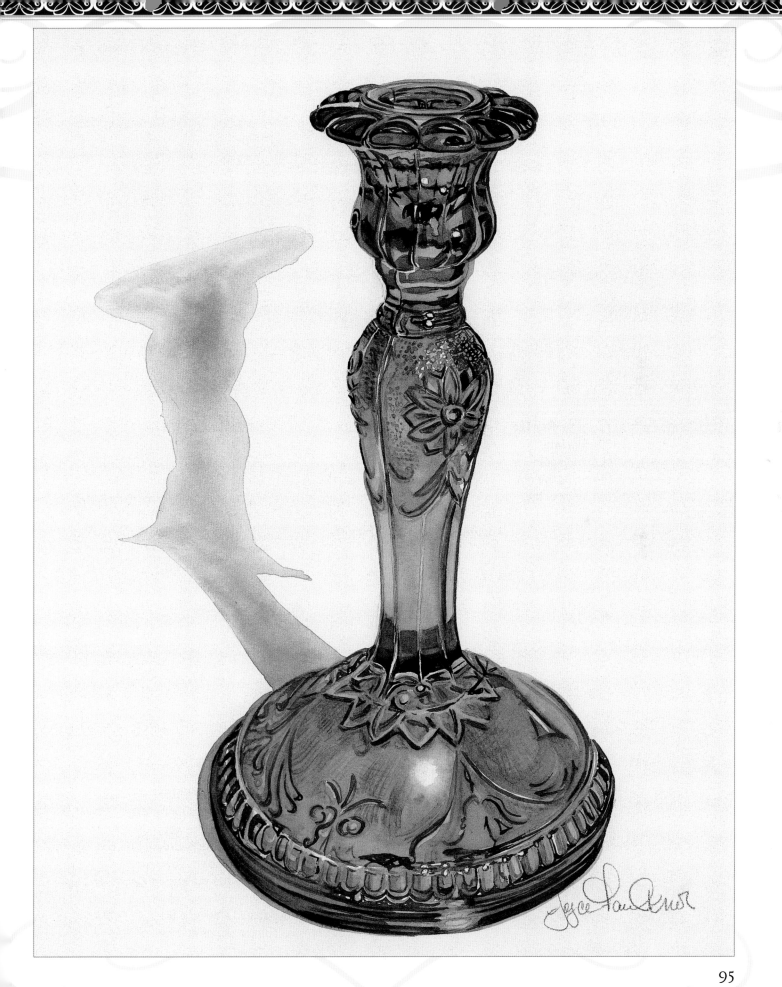

The Anatomy of Cut Crystal

Breaking down the key points of the crystal vase will help you get a better understanding of the shapes within the cut crystal. Enlarging the size of the design will help us explore the shapes in more detail.

When you first begin to paint cut crystal, paint larger than you normally would. It may seem as though you are taking on a bigger task, but in actuality it is easier, and you will have a better understanding of what you are painting.

The Main Reference Photo
This reference of the entire vase can be broken down into smaller pieces to help you focus on individual shapes.

SUPPLIES

~SURFACE~
140-lb. (300gsm) cold-pressed paper

~BRUSHES~
No. 6 round
¼-inch (6mm) flat

~PIGMENTS~
Burnt Sienna
New Gamboge
Permanent Alizarin Crimson
Phthalo Turquoise
Winsor Green (Blue Shade)

Reference Photo, Rim

PAINT THE RIM

The tricky part about painting the rim is that in our minds we think we know what the shape is. You need to forget what you "know" the shape is and instead just paint the shapes that you see.

1 BEGIN THE RIM
Begin with the largest shapes. Mix Winsor Green (Blue Shade) and Permanent Alizarin Crimson for a dark gray. Lay in the colors on the darkest side using the ¼-inch (6mm) flat. Rinse your brush. Then, with a damp brush, pull the pigment to a lighter value.

2 ADD THE SMALL SHAPES TO THE RIM
Use all the same shapes and techniques as in step 1 and the ¼-inch (6mm) flat, or for the smallest shapes use the no. 6 round. These shapes collectively create the rim. The biggest misconception is that the rim of a vase is painted with one continuous line. But it is more realistic to have the shapes create the rim.

3 GLAZE THE RIM
Glaze the full surface of the rim using the no. 6 round. While the glaze is wet, drop in New Gamboge and Permanent Alizarin Crimson.

PAINT THE BLADE

There is always a light side and a dark side to a blade in cut crystal, no matter what the design or pattern is. The different sides have more than flat blacks and white. They are loaded with values in between that create the movement and sparkle within the cut crystal.

Reference Photo, Blade

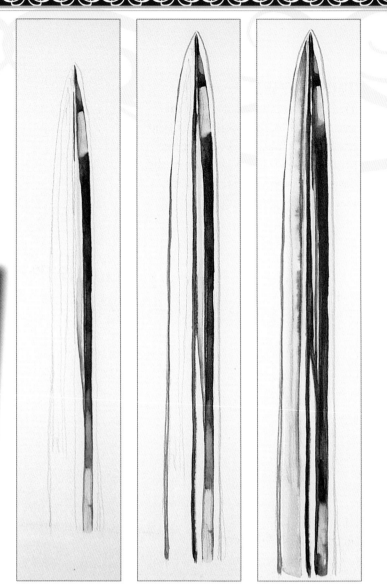

1 BEGIN WITH THE DARK SIDE

Using the same dark gray mixture you used for step 1 in Paint the Rim, begin the dark gray edge. Then, switch from the dark gray to a light tint of Phthalo Turquoise then back to dark gray again, lightening the gray mixture at the end with more water.

2 PAINT THE CENTER

Use your no. 6 round and the Permanent Alizarin Crimson and Winsor Green (Blue Shade) mixture to paint down the center of the dividing line of the blade. This is where the cut crystal "pops."

3 PAINT THE LIGHT SIDE LAST

Switch to your ¼-inch (6mm) flat and add Phthalo Turquoise to your gray mixture to represent the blue highlights that appear in the reference photo. Use the wet-into-wet technique to get the lighter value and soft edges.

THE CROWN

The crown is the focal point of this vase. Every design on any piece of cut crystal has a focal point. The center of this design is sharp in focus. As the design turns, it has an out-of-focus view with soft edges.

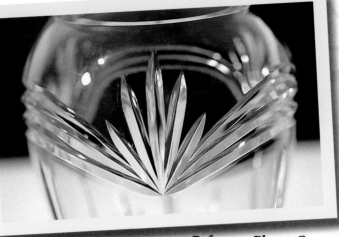

Reference Photo, Crown

1 BEGIN WITH THE DARKEST SHAPES IN THE FAN
Mix another puddle of the same dark gray you used for the rim and the blade. Work either right to left or left to right, whichever is most comfortable for you. Paint only the fan area right now. Using the ¼-inch (6mm) flat, lay pigment down the center of the blade, finishing the shape with a soft edge. As you are painting the dark value, notice the yellow and purple highlights in the fan area. Premix New Gamboge and Phthalo Turquoise with Permanent Alizarin Crimson for the purple so that you can drop this in as you go.

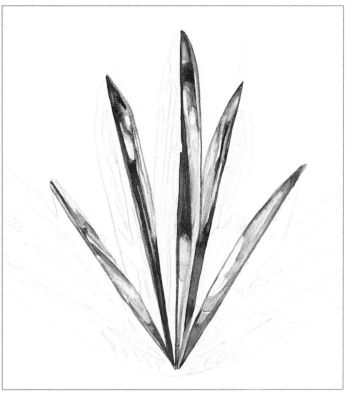

2 FINISH THE DARK SIDES OF THE FAN
Using the dark gray mixture from before and your no. 6 round, create a good point and sharpen the edges to create an even better edge on the fan's darkest sides. Notice that the light changes and the dark side shifts from right to left.

3 PAINT THE DARKS ON THE ARCH

Mix another gray puddle using Permanent Alizarin Crimson and Winsor Green (Blue Shade). Using your ¼-inch (6mm) flat, add the darks, starting at the top of each arch and working your way to the bottom. Incorporate a hint of Burnt Sienna diluted with water as you paint the grays. Notice the edges of the shapes are sharp, but as the arch recedes back the edges become soft and out of focus.

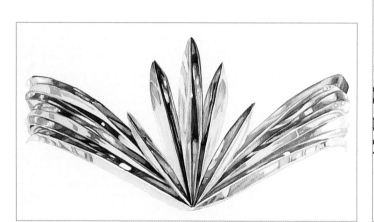

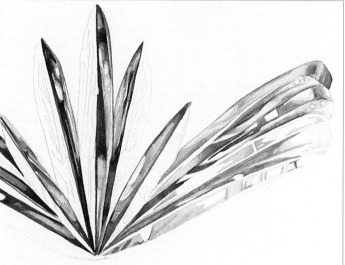

4 PAINT THE LIGHTER SIDES OF THE ARCHES

Still using your ¼-inch (6mm) flat, lighten the gray mixture and paint in the medium-to-light shapes that are in the arch.

5 PAINT THE LIGHT SIDES OF THE BLADES TO FINISH

Lighten that gray mixture even more and glaze in the light sides of the blades. This should be your lightest value except for the whites.

Putting Cut Crystal Together

Let's put it all together. Even though the shapes are much smaller than in the previous demonstrations, you now have a good idea of what you are looking at. Begin painting this vase by locating all the darkest shapes within.

Deciding when to paint your background is a purely preference-based decision. Generally, I paint the background last. However, with this piece, I decided to paint it first to give me a little more to go on to see the edges and to help incorporate that background color into the crystal.

SUPPLIES

~SURFACE~
140-lb. (300gsm) cold-pressed paper

~BRUSHES~
No. 6 round
¼-inch (6mm) flat
½-inch (12mm) one-stroke
1½-inch (38cm) one-stroke

~PIGMENTS~
Burnt Sienna
New Gamboge
Permanent Alizarin Crimson
Permanent Rose
Phthalo Turquoise
Winsor Green (Blue Shade)

~OTHER~
HB pencil

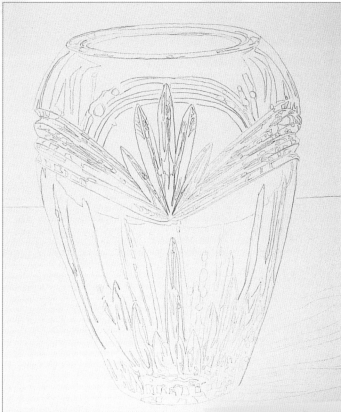

Line Drawing

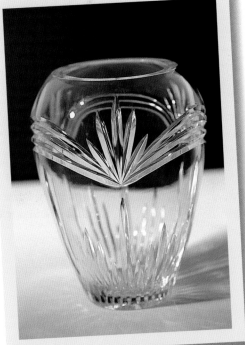

Reference Photo

1 BEGIN WITH THE BACKGROUND

Beginning with the background will help you establish the darkest values. Mix Permanent Alizarin Crimson, Winsor Green (Blue Shade) and Burnt Sienna for a rich black. Use the wet-on-dry technique and be sure your pigment is moist and not too thick. With your 1½-inch (38mm) one-stroke, evenly apply the pigment, reloading your brush throughout the process. Do not go back into areas you've already painted; that will leave brush strokes. If your background isn't dark enough or if brush strokes appear, don't panic. Just allow the background to dry completely, remix your pigment and reapply the same gentle strokes.

2 PAINT THE DARKEST SHAPES

Use your 1½-inch (38mm) one-stroke and the wet-into-wet method to apply a slightly lighter version of the same mixture you used in step 1. This will give the inside of the vase a more transparent look compared to the background. Begin from the top and work your way to the bottom, painting all the largest darkest values first. The opening of the vase has the background shining through. Place some of lighter values in this area so the pigment doesn't became flat.

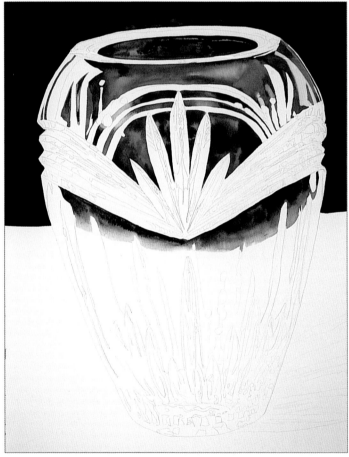

3 WORK YOUR WAY DOWN

The next large dark values are in the upper portion of the vase. This, too, will have a transparent look. But you will also want the values to be a little lighter because there are two layers of glass through which the background is penetrating. So continue lightening that mixture and apply the paint using your 1½-inch (38mm) one-stroke.

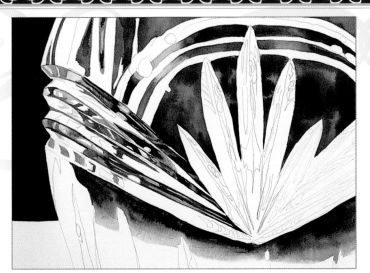

4 PAINT THE CUTS

Go back to your dark mixture from step 1 and begin all the darkest values in the cut crystals with a ¼-inch (6mm) flat. Also premix the prism colors that reflect into the dark values: Burnt Sienna and Permanent Alizarin Crimson; Phthalo Turquoise and Permanent Rose; and New Gamboge and Burnt Sienna.

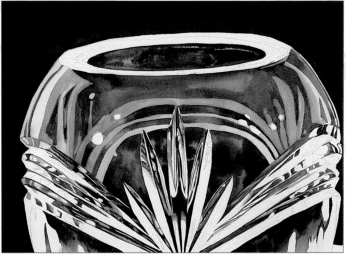

5 GLAZE THE TOP PORTION OF THE DARK SIDE

One side of each cut in the crystal is dark and one is light. The light is created by the beveled edge running down the middle. Begin with a medium value, mixing Permanent Alizarin Crimson and Winsor Green (Blue Shade.) Using a 1½-inch (38mm) one-stroke, glaze over the whole dark section except for the highlights. Add a hint of Phthalo Turquoise anywhere you see the prism colors.

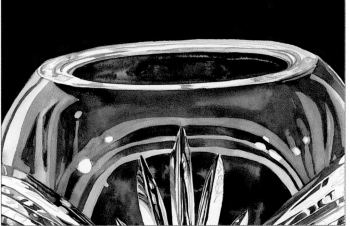

6 PAINT THE RIM

Begin the rim with a medium gray pigment (Permanent Alizarin Crimson and Winsor Green [Blue Shade]), using the no. 6 round. Load the brush so that it is very moist. Follow the rim, using shorter strokes to imitate the quarter-circles that are lying flat on this surface. Drop in a hint of the New Gamboge and Permanent Alizarin Crimson.

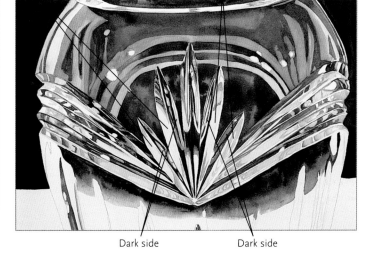

Light side Light side

Dark side Dark side

7 PAINT THE CRYSTAL'S LIGHT SIDE

Begin with the crown area. While painting the light side of the cut crystal, notice that there are medium dark and medium light values throughout. Add at least three value changes on the light side, continuing with the arches.

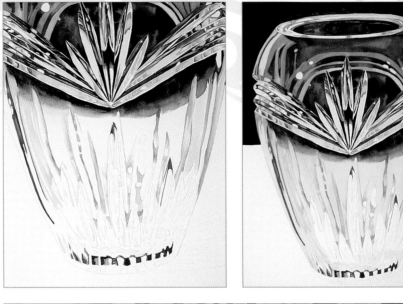

8 PAINT THE BACKSIDE OF THE VASE

Focus now on the cut crystal from the other side as seen through the vase. The image is out of focus. Use medium-to-light values of your gray mixture (Permanent Alizarin Crimson and Winsor Green [Blue Shade]) and a loose stroke with your ¼-inch (6mm) flat. This should not be as tight as the crystal that is in focus.

9 GLAZE THE BACKSIDE OF THE VASE

Mix a glaze of gray with the ratio of 5 percent pigment to 95 percent water. It should be almost clear water with just a hint of gray. Use slow, gentle strokes and a light touch with your 1½-inch (38mm) one-stroke. Once you have applied the wash, leave the pigment alone. You don't want to overwork it.

10 PAINT THE BLADES AT THE BASE OF THE VASE

Remember, you don't have to paint everything exactly as it appears in the reference photo. Some of the blades on the reference photo are out of focus, but we're not going to paint them that way. Once you have practiced painting blades, you'll be able to enhance the blurry ones.

Begin with the blade in the center of the lower portion of the vase. Find the center line and lay down a light middle value of your gray mixture. For the lighter values, add hints of Phthalo Turquoise and Burnt Sienna with New Gamboge. Continue with the right side (the darkest portion of the blade).

11 FINISH THE LIGHTER SIDE OF THE CENTER BLADE

Enhance the prism colors as you finish the blade with the lightest values of your gray mixture. Also, notice that you can see the base of the vase reflecting through the cut crystal. Remember that the blade design is in front of the back portion of the base, so allow the base to reflect through, and at the same time, keep the design of the blade in front of the baseline.

12 FINISH PAINTING THE BLADE DESIGN AT THE BASE

There are just a few abstract shapes that are darker than the base gray. Drop in the Phthalo Turquoise at the base of the vase on the left side.

13 ADD THE SHADOW TO FINISH

Mix a medium-value gray. Using the wet-into-wet technique and your ½-inch (12mm) one-stroke, apply clear water anywhere you want the gray to float into. Let it dry. Then glaze with an even lighter gray; while that is wet, drop in New Gamboge, Phthalo Turquoise and Permanent Rose.

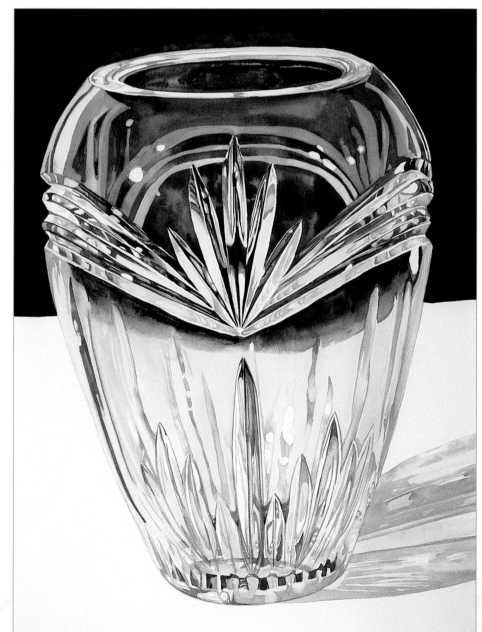

Cut Crystal on a Reflective Surface

No matter what the design, cut crystal will always have a light side and a dark side. Now that you've learned how to paint both sides and assemble the different parts of cut crystal, let's try a slightly more complex piece.

While the design for the crystal itself is simple, you have a few challenges. First, you'll basically be painting this subject twice. Also, the bowl's design appears one way on the actual bowl, but in the reflection it's not only upside down, but slightly altered with the underside showing.

SUPPLIES

~SURFACE~
140-lb. (300gsm) cold-pressed paper

~BRUSHES~
No. 6 round
⅛-inch (3mm) scrubber
¼-inch (6mm) flat
1-inch (25mm) one-stroke

~PIGMENTS~
Permanent Alizarin Crimson
Phthalo Turquoise
Quinacridone Gold
Winsor Green (Blue Shade)

~OTHER~
HB pencil
Eraser

1 BEGIN THE BACKGROUND

The elements that will give this still life a feeling of being on a mirror are the outer edges, which will be painted black. The cherry stems split the page in two. This will allow you to paint the background in separate steps, beginning with the darkest side and moving to the lightest.

Mix a light and medium-light gray using Permanent Alizarin Crimson and Winsor Green (Blue Shade). It should look like a dark silver gray on your palette. The wet-into-wet technique will lighten the value. Using a 1-inch (25mm) one-stroke, wet the surface of the background and lay in the graded wash.

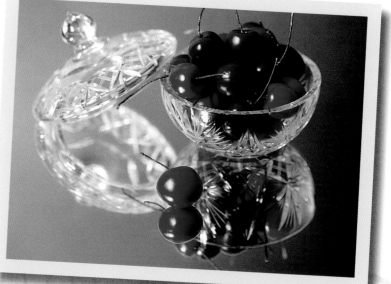

Reference Photo

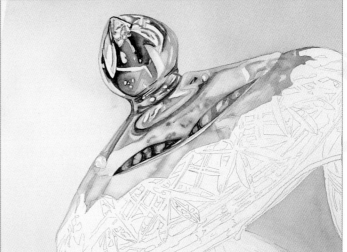

2 APPLY THE DARKEST VALUES

Beginning with the top left, work on the lid of the bowl. The darkest shapes in the handle have soft edges. Mix Permanent Alizarin Crimson and Winsor Green (Blue Shade) for a cool silver gray. Using the no. 6 round and the wet-into-wet technique, begin the shapes. As you lay down the darkest pigment, clean your brush and gently brush the pigment to a lighter value with a soft edge.

3 LOOK FOR STARTING AND STOPPING POINTS

As you work your way down the lid, look for starting and stopping points. When you find yourself at a good stopping point, move on to the next shape. Just be sure that the shapes you are working on do not touch or you will create blossoms, and this is not the time for that. You will create separate shapes within the lid this way.

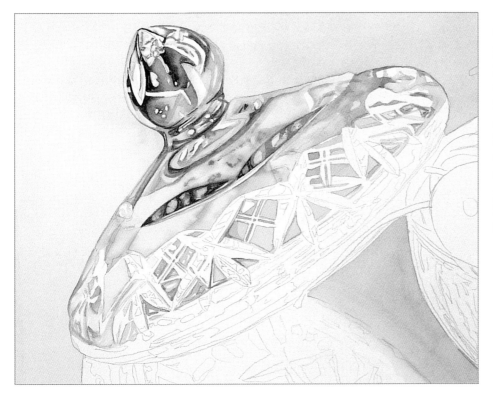

4 BEGIN PAINTING THE NEGATIVE SPACE

Using a ¼-inch (6mm) flat, begin painting the negative gray spaces between cuts. This hue should be a shade darker than the background. Some of the gray shapes facing directly toward you are flat, but as these move away from the center you will see two or three shades within the shapes. Trust the shapes that you have drawn in. If the reference photo is a little unclear as to the distorted shapes, just follow your pencil lines.

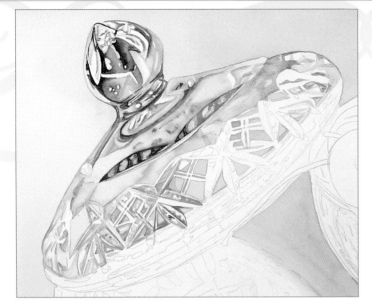

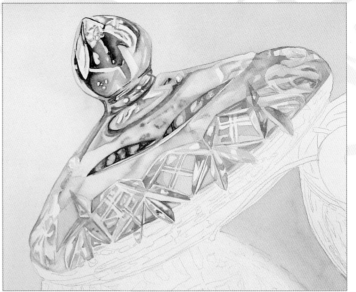

5 BEGIN PAINTING THE CUT CRYSTAL

Still using your ¼-inch (6mm) flat, fill in the variety of values within the design. Begin with the darkest side. (Doing all the dark sides first helps keep everything in order.) Add a bit of Quinacridone Gold and Winsor Green (Blue Shade) as you go to show the stems reflecting through.

6 PAINT THE LID

Continue painting all the cut crystal that is on the lid. As the lid turns, the cut crystal will become distorted. Just treat these distorted parts as shapes. Notice some edges are softer without much detail and some of the cherries and stems reflect onto the lid.

Mix Permanent Alizarin Crimson and Quinacridone Gold for the cherries. Use a Quinacridone Gold and Winsor Green (Blue Shade) mixture for the stem.

7 PAINT THE BOTTOM EDGE OF THE LID

The bottom edge has lots of darks that will help anchor the lid. First paint in the gray values. Some of the shapes have golds and reds. To have these colors blend with the gray, use a wet-into-wet technique and, as you drop in the gray, Quinacridone Gold and Permanent Alizarin Crimson, allow the colors to bleed together. Exaggerate the hints of the reds and golds.

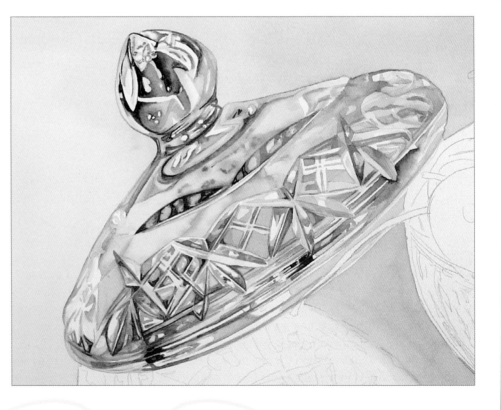

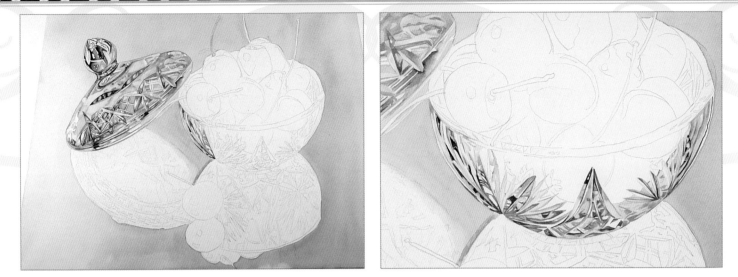

8 BEGIN THE BOWL

Begin the bowl from the lower left side, painting what you see. The small shapes within the crystal will add depth. Use your darkest gray to begin with and as you approach any of the reds, add them. For the lighter reds, use a Permanent Alizarin Crimson and Quinacridone Gold mixture. For the darker ones, mix a Permanent Alizarin Crimson and Phthalo Turquoise puddle. Leave all the reds of the cherries that are above the crystal for later. If you see that the shapes are so distorted that they are hard to read, just lightly paint in some of the shapes.

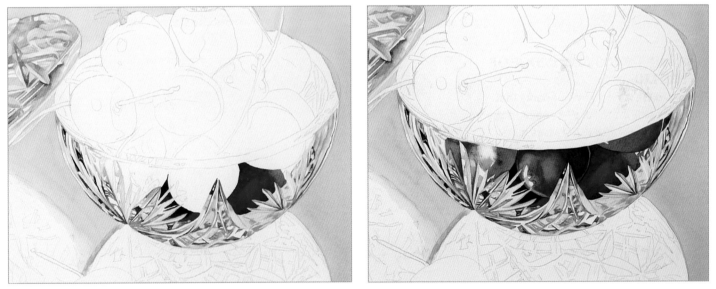

9 PAINT THE CHERRIES IN THE BOWL

Mix Permanent Alizarin Crimson and Phthalo Turquoise for the darker portions of the cherries. Mix Permanent Alizarin Crimson and Quinacridone Gold for the lighter portions of the cherries. From these puddles you will be able to achieve the many values. Try for at least five value changes.

Using a no. 6 round brush, begin with your darkest value. Add the lighter values as you come to them. Now is when the crystal will begin to pop. When the cherries are painted in, you may want to take a break and study the bowl to see where you can add any hard edges to enhance the cuts.

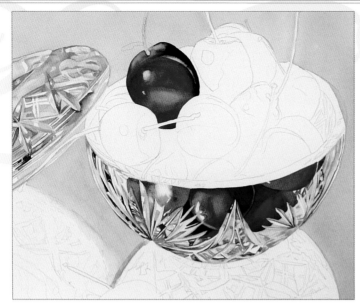

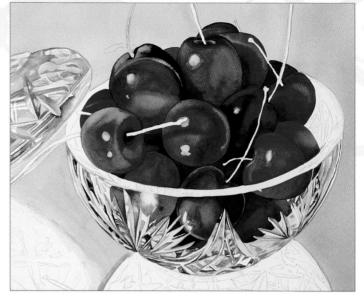

10 FINISH THE CHERRIES

Using the same pigments you mixed in step 9, start at the top and work on the darkest cherries first. Add the darkest value using a no. 6 round. Clean your brush and reload it with the middle value red. Just slightly touch the dark red with the middle value to blend the two for a subtle change. If the cherry has a third value change, repeat this process. Leave the white of the paper for the highlights. To get a highlight effect, loosen the edge of pigment around the highlight for a soft edge.

11 FINISH THE BOWL

The rim has many shapes that reflect onto the flat surface. First finish the inside of the bowl using the no. 6 round and a light gray mixture of Permanent Alizarin Crimson and Winsor Green (Blue Shade). This will give you a better guide to paint the rim.

For the rim, paint all the dark grays. The darkest value on the rim has a purple hue, so when mixing your gray add a little more Permanent Alizarin Crimson. Glaze the rim and add Phthalo Turquoise and Quinacridone Gold for a prism accent.

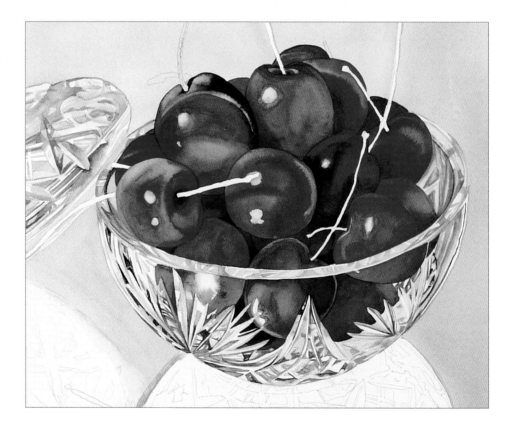

12 BEGIN THE REFLECTIONS

The wet-into-wet technique will help you achieve the out-of-focus look of the reflection of the lid. Wet the surface and paint in a middle gray value. Allow the pigment to have movement within the shapes. Once the paint is dry, loosen the edges on the reflective cut crystal shapes using a ⅛-inch (3mm) scrubber. (My friend Guy showed me this trick—thank you, Guy!) Just wet the surface where you want the blurred edge. Let the water sit for thirty seconds, then scrub lightly. Glaze the shape with a lighter value. Let this portion of the painting dry thoroughly, then erase your pencil marks to give you a better idea of the values you've painted so far.

If you are having a hard time reading the light values of the reflective lid, leave this portion alone until the rest of the reflective images are painted.

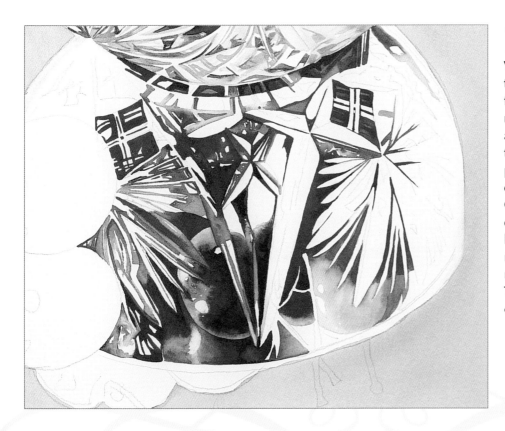

13 BEGIN THE REFLECTION OF THE BOWL

With the pigment that you mixed for the cherries, paint the darkest shapes first. This will give you a good point of reference for where the cut crystal starts and stops. Those negative shapes will then outline the cut crystal, creating the pattern. Begin with the biggest, darkest red values. Mix Permanent Alizarin Crimson and Phthalo Turquoise for a dark, rich red. To keep the shape from looking flat, change the value from the rich, deep red to a little lighter using mostly Permanent Alizarin Crimson. The shapes now are either rounded or they end with a point.

14 PAINT THE REFLECTION'S MEDIUM VALUES

Now that the darkest shapes are all in place, the medium values will be easier to read. Mix Permanent Alizarin Crimson with a hint of the Quinacridone Gold for the brighter reds. Work from the top of the reflection to the bottom. There will be some areas with the medium-to-dark values, so prepare a separate puddle of pigment so that you can paint that as you are adding the bright reds.

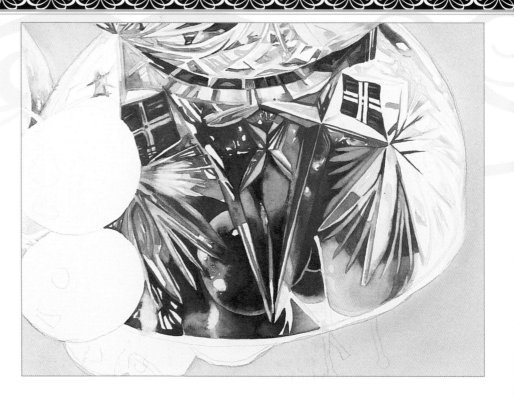

15 FINISH THE CRYSTAL IN THE REFLECTION

Mix the lightest values of grays (Permanent Alizarin Crimson and Winsor Green [Blue Shade]) to light reds (Permanent Alizarin Crimson and Quinacridone Gold) for the remaining shapes. Use these mixtures, along with a hint of pure Quinacridone Gold, to finish the crystal's reflection. Notice that the crystal fan pattern on both sides of the bowl no longer looks like a fan pattern. It runs up and down the sides, giving the bowl more shapes.

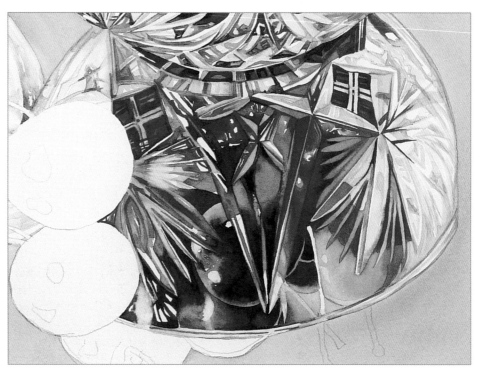

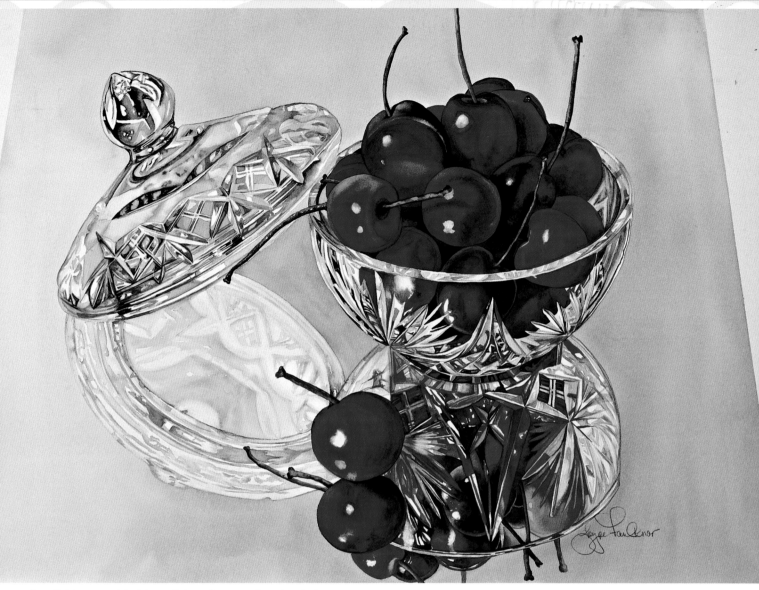

16 COMPLETE THE STEMS AND CHERRIES

Use the method from step 10 to complete the last cherry and the rest of the cherry reflections. Allow this to dry.

Use the wet-into-wet technique for the stems. Mix Quinacridone Gold and Winsor Green (Blue Shade) for the lightest part of the stems. Mix Quinacridone Gold and Winsor Green (Blue Shade) with a hint of Permanent Alizarin Crimson for the darker values on the stems. Then, using your no. 6 round, apply the Quinacridone Gold and Winsor Green (Blue Shade) pigment. While the surface of the stem is still wet, add the Quinacridone Gold, Winsor Green (Blue Shade) and Permanent Alizarin Crimson to only the edges of the stems. Allow the pigment to flow.

Still Life With Seven Pieces of Glass

Setting up a still life with numerous pieces of glass is a wonderful experiment in seeing glass reflect, refract and distort. Picking your favorite pieces is a great way of starting a large still life. Make sure that the pieces are a variety of sizes and that there is a flow to the composition.

Even though I thought I had checked through my list, I still see a few errors in the reference photo, but nothing that cannot be fixed. First, the candlestick on the far right is level with the blue decanter. I'll enlarge the piece and transfer it on paper as a larger candlestick. Next, I have an issue with the leaf that is jammed into the pink vase, so I'm eliminating it and filling that space with the rim of the vase.

Line Drawing
Include lots of detail in your line drawing. This will give you the confidence to paint, knowing your information is there for you. Four of the glass pieces are clear, which means that the same dark values can be used throughout these four pieces.

SUPPLIES

~SURFACE~
140-lb. (300gsm) cold-pressed paper

~BRUSHES~
No. 6 round
¼-inch (6mm) flat
1½-inch (38mm) one-stroke

~PIGMENTS~
Burnt Sienna
New Gamboge
Permanent Alizarin Crimson
Permanent Rose
Phthalo Turquoise
Quinacridone Gold
Winsor Blue (Red Shade)
Winsor Green (Blue Shade)

~OTHER~
HB pencil
Eraser
Transfer paper

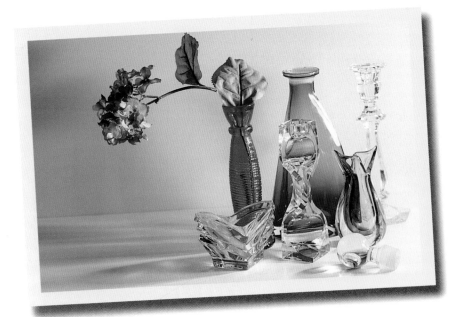

Reference Photo

1 PAINT ALL THE DARK GRAYS

Mix the darkest value using Permanent Alizarin Crimson and Winsor Green (Blue Shade). Paint all the darkest values using your no. 6 round and the ¼-inch (6mm) flat, depending on the shape. Remember that you are setting up the shapes for glazing.

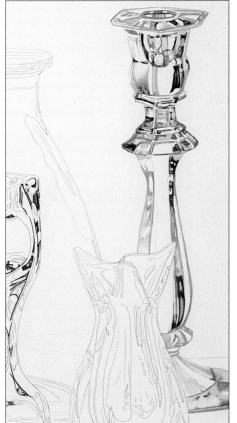

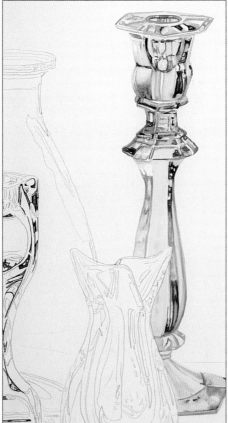

2 PAINT THE LARGE CANDLESTICK

Add water to the pigment you used for the darkest values to get medium-dark and medium puddles of pigment. Using your ¼-inch (6mm) flat, begin at the top and add medium-dark values right next to the dark grays. Work your way down, adding the medium values where they occur in the reference photo.

3 FINISH THE LARGE CANDLESTICK

Add a hint of the premixed gray value to Phthalo Turquoise to get a blue-gray for the final glaze on the candlestick. Mix Burnt Sienna with Permanent Alizarin Crimson for the warm glow that is reflected onto the left side of the candlestick.

As you are glazing in the blue-gray, drop in the Burnt Sienna mixture while the wash is still wet so it will bleed into an easy gradation. Here is a great opportunity to take creative license and add extra "pop" to the candlestick—add a little more of the warmth of the reflective blue from the decanter next to the candlestick.

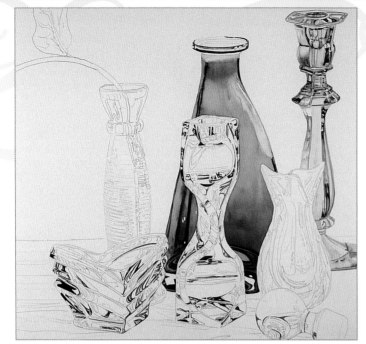

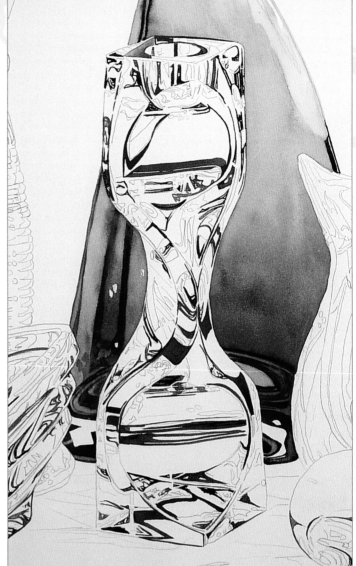

4 PAINT THE BLUE DECANTER

Using pure Winsor Blue (Red Shade), paint the darkest shapes with your 1½-inch (38mm) one-stroke. Be sure your pigment has just enough water mixed into the blue puddle so that the brush flows and the pigment releases properly.

To glaze the decanter, add water to the blue pigment. Mix two puddles: one medium value and one light value. With a 1½-inch (38mm) one-stroke, glaze over the entire body, stopping at the highlight and the ring around the neck. Glaze with the lightest value. While that glaze is wet, almost at the drying stage, add the medium value and allow the pigment to bleed.

6 PAINT THE HOURGLASS

The hourglass is actually a candlestick holder. Use the blue you mixed for the decanter to add the largest and darkest values.

5 FINISH THE RIM OF THE DECANTER

Paint the medium dark lines that run around the rim using the no. 6 round and medium value of Winsor Blue (Red Shade). Once that is dry, glaze over it with the light value of Winsor Blue (Red Shade).

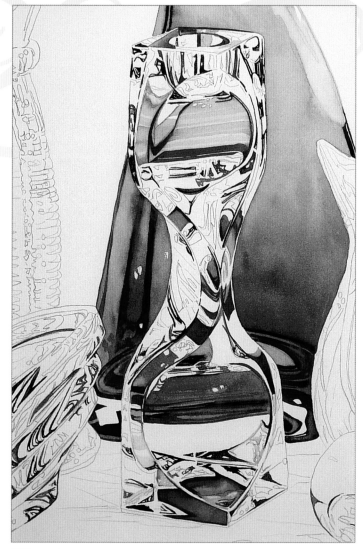

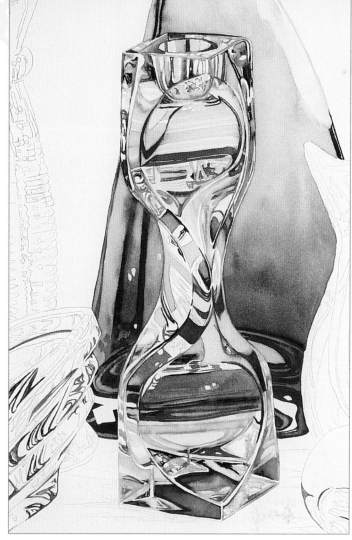

7 GLAZE OVER THE DARK BLUE SHAPES

Glaze over the darkest blue shapes with a medium-dark glaze of Winsor Blue (Red Shade) and your ¼-inch (6mm) flat. Once you have completed that, go ahead and glaze over the medium to light blue shapes.

8 ADD GRAY VALUES

Mix three puddles of gray values, from medium dark to light using Permanent Alizarin Crimson and Winsor Green (Blue Shade). Beginning with the medium dark value, paint these shapes into the hourglass. Start at the top and paint in the dark medium values. As you're painting, you'll come across medium and light values; paint those as you work your way down. If you come across a section that is not making sense, skip it and keep moving down. Eventually those shapes that were hard to read or understand will become clear. You will see some pink shapes that are reflected from the pink vase; you'll paint these later.

Stand back and look at the painting. At this point the painting has a very cool temperature, but the other vases will warm up this still life.

9 ADD THE DARKEST VALUE FOR THE STOPPER

The stopper is the lid for the decanter. It picks up some wonderful colors from the other glass pieces. For its darkest value, use pure Winsor Blue (Red Shade) and the no. 6 round. This shape moves from a dark blue to a value that's a little lighter. First paint the darkest shape. Allow it to dry a bit. Then add the next lighter value. Allow the two values to slightly bleed together, just enough to get that soft edge.

10 FINISH THE STOPPER

The stopper shapes have a beautiful way of wrapping around the glass. Keep this in mind as you paint. Follow the curve, and the shapes will begin to make sense. Mix medium light and light values of gray. Using the no. 6 round, paint in the darker of the two values first, keeping in mind that most of the stopper is in the lighter value.

11 PAINT THE DARK VALUES ON THE PINK VASE

Begin with the darkest and medium dark values, including each ring that runs around the vase. This may seem tedious, but the results will be fabulous.

Mix Permanent Rose with a hint of Phthalo Turquoise to get a striking purple. Use this purple and a very moist no. 6 round for all the darkest values. The brush should move smoothly. Work from the top to the bottom, and paint into the V-shaped candy jar wherever you see the darker values.

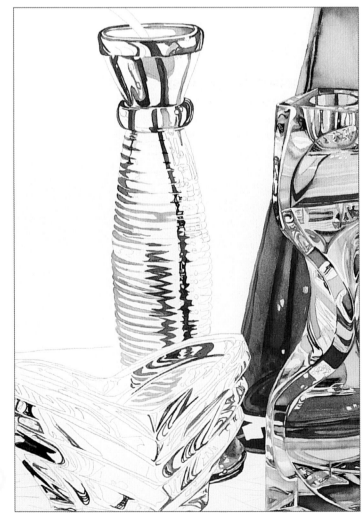

12 PAINT THE DARK PINK VALUES AND BEGIN GLAZING

Mix Permanent Rose with a hint of Phthalo Turquoise using half pigment to half water. Using a ¼-inch (6mm) flat, add the slight value changes within the pink hue of the vase area as you follow the curves. Paint just the rim and neck. Let it dry completely.

With Permanent Rose (20 percent pigment and 80 percent water) glaze over the rim and neck.

13 GLAZE THE MEDIUM VALUE ON THE VASE

Apply medium light Permanent Rose on the vase using your ¼-inch (6mm) flat, following the curves as you glaze. Leave the white highlights, the lightest value of Permanent Rose and the right side of the vase with the blue glow. Also, go ahead and paint in the pinks in the other two pieces of glass.

14 FINISH THE PINK VASE

Still using your ¼-inch (6mm) flat, mix 5 percent Permanent Rose and 95 percent water for the lightest value on this vase. Still don't paint over the highlights or the blue reflective color from the decanter.

Reflective shapes from the blue decanter are running up and down the right-hand side of this vase. Use Phthalo Turquoise to provide that glow.

Notice now how there is movement on the glass that is created with just a few value changes.

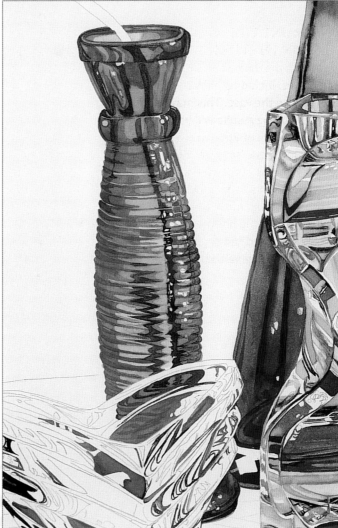

15 PAINT THE V-SHAPED CANDY JAR

There is a rhythm to this piece of glass. Note the repetitive shapes as you paint. Mix medium dark to medium light gray values along with a light gray with a hint of Permanent Rose. Use your ¼-inch (6mm) flat and no. 6 round (depending on the shape you're painting). Locate the medium dark values in the reference photo. Most are next to the darkest values you have already finished. Start with the first rim. If you get stuck, just continue to paint the shapes you are sure of. The other shapes will eventually make sense. Once you've finished, allow it to dry, erase all the pencil marks and stand back to see if you may need to add a darker value or another hint of color.

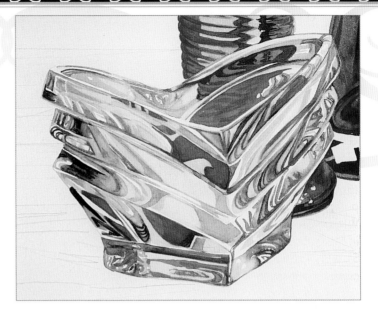

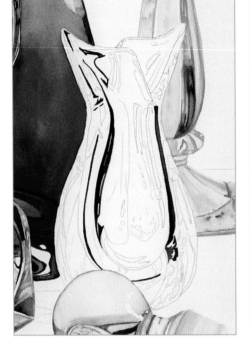

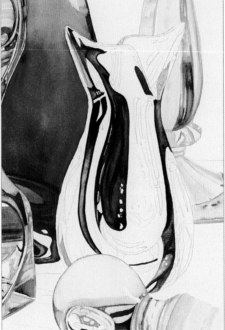

16 PAINT THE DARKS IN THE ITALIAN GLASS VASE

Mix Winsor Blue (Red Shade) and Winsor Green (Blue Shade) to get the darkest blue value. Using your no. 6 round, paint the darkest shapes. Leave a hint of light coming through, even though it does not show in the reference photo. This will give the piece a transparent look.

17 PAINT THE REST OF THE BLUES

Paint the rest of the blues using the ¼-inch flat (6mm), darkest to lightest.

18 PAINT THE GREEN TO GOLD HUES

This part moves from a Winsor Green (Blue Shade) to a Quinacridone Gold and Burnt Sienna mixture. Using the wet-into-wet technique and your ¼-inch (6mm) flat, mix up the two puddles of pigment and begin at the top with the Winsor Green (Blue Shade). Gently tap in the Quinacridone Gold and Burnt Sienna mixture at the bottom of the curve.

19 PAINT THE DARK GOLDS AND GREENS

Mix Quinacridone Gold and Burnt Sienna with a hint of Winsor Blue (Red Shade) to create the darkest value of the gold. Locate these shapes on the reference photo and paint them in with the no. 6 round. Add the golds and greens in the stopper, too.

20 ADD THE GRAYS IN THE VASE

Mix a light gray. Using your no. 6 round, paint in the gray shapes that are seen in the lightest gold areas.

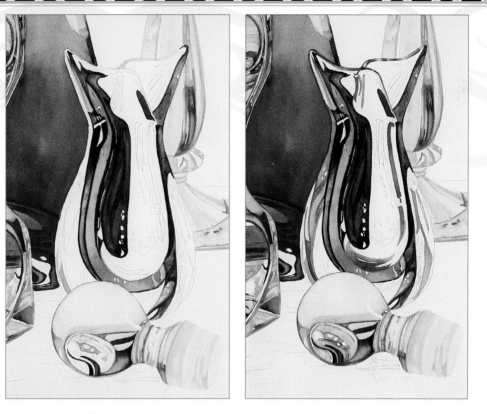

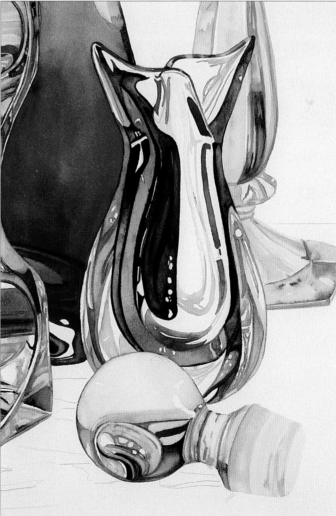

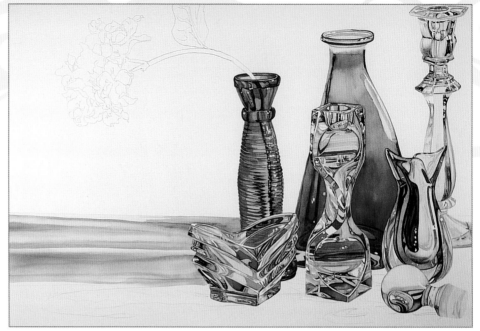

21 GLAZE THE LIGHTEST VALUE OF GOLD

Mix 5 percent Quinacridone Gold with 95 percent water to get the light gold glaze. Using the 1½-inch (38mm) one-stroke, glaze over the gray shapes.

22 BEGIN THE SHADOWS

Mix a light blue wash from the Phthalo Turquoise and a light gray using Permanent Alizarin Crimson and Winsor Green (Blue Shade). Have the two puddles ready along with two brushes for each puddle of pigment. For the back shadow, use a 1½-inch (38mm) one-stroke to paint in the blue. While that is still wet, lay the gray over the blue, making V-shapes, but still leaving some of the blue showing.

Repeat the process, but add Permanent Rose instead of the Phthalo Turquoise.

23 PAINT THE CANDY JAR SHADOW

For the small round shadow, use the wet-into-wet process, leaving the paper dry where there are highlights. Mix a medium-to-dark gray. While the paper is wet, use your no. 6 round to paint the dark outer circle. Then, use the 1½-inch (38mm) one-stroke to lay in the lightest gray and the darkest gray.

Repeat the same procedure for the shadows of the stopper and the hourglass. The last two small shadows are a flat gray.

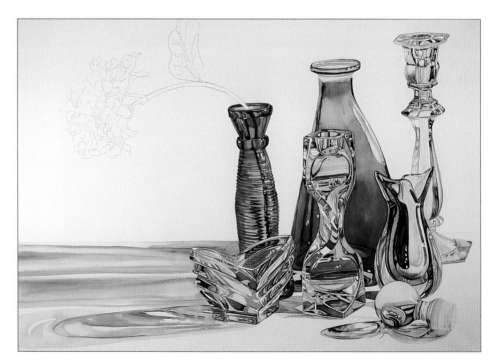

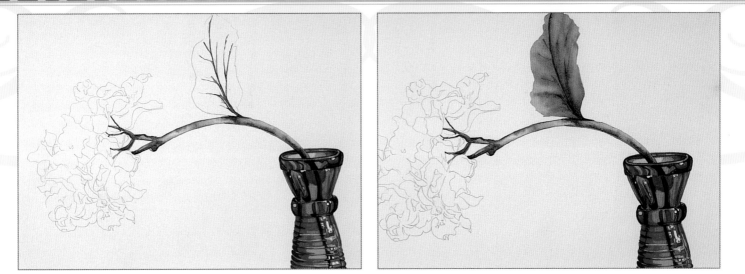

24 PAINT THE STEM

Mix Winsor Green (Blue Shade) and Burnt Sienna. Using the wet-into-wet technique and the no. 6 round, lay in the pigment on the dark side of the stem so that the pigment floats to the lighter side and gives the stem a round feel.

Continue with the same pigment and paint in the veins of the leaf. Once the pigment is dry, mix a lighter wash of the Winsor Green (Blue Shade) and Burnt Sienna. Paint the leaf, and while the pigment is still wet, drop in darker values of the Winsor Green (Blue Shade) and Burnt Sienna where you see them.

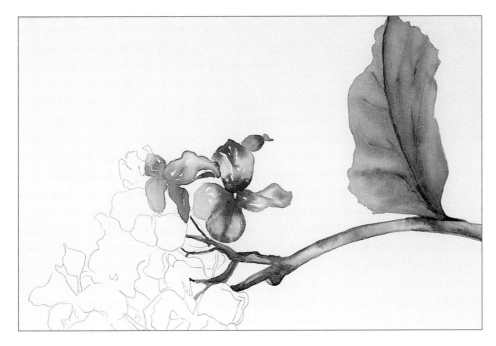

25 PAINT THE PETALS ONE AT A TIME

Mix two puddles of pigment: a very light value of Permanent Rose and a very dark value of Permanent Rose and Phthalo Turquoise.

Using your no. 6 round, paint the petal with the light value. While the petal is still wet, drop in the Permanent Rose and Phthalo Turquoise mixture. Repeat the process until you've completed the petals.

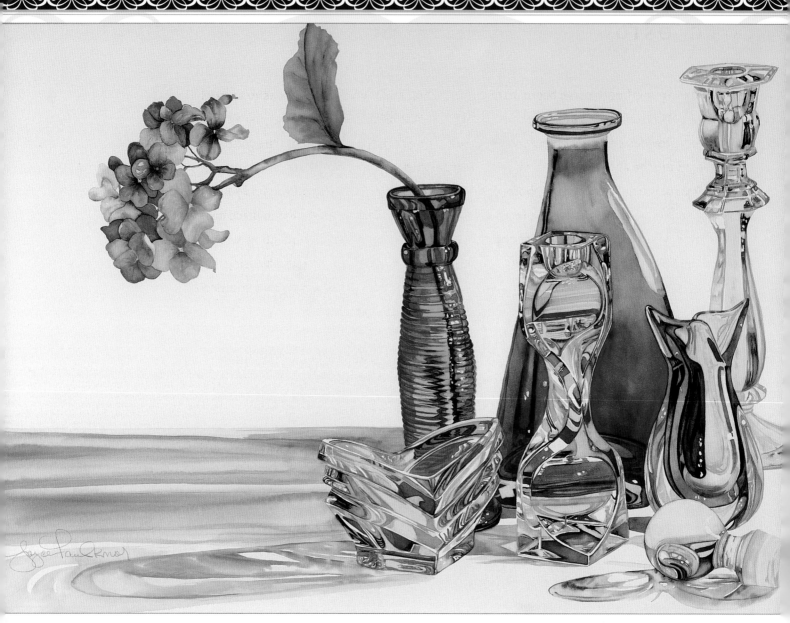

26 COMPLETE THE PETALS TO FINISH

Using the same technique as in step 25 finish the yellow and pink petals. For the yellow, use 5 percent New Gamboge with 95 percent water. For the pink, make a mixture of Permanent Rose and a hint of Quinacridone Gold.

CONCLUSION

I hope that from this book you've begun to understand and find the passion and desire to paint from glass, cut crystal objects and reflective surfaces. This subject is forever giving: Just a slight turn of your head provides something new and exciting to see. The light reflecting into the glass is what is exciting, as are the abstract shapes, pushing your palette beyond what is there, and taking a little bit of information that the reference photo gives you and making it your own. If you find your passion, stick with the subject and believe in what you are painting. The rest will fall into place for you.

Whether you are painting for profit or for pleasure, never forget the joy of painting, which will always shine through in your work. Waking up and looking forward to painting is a blessing. I hope that all of you will find joy and happiness when painting. Today's lesson is tomorrow's knowledge.

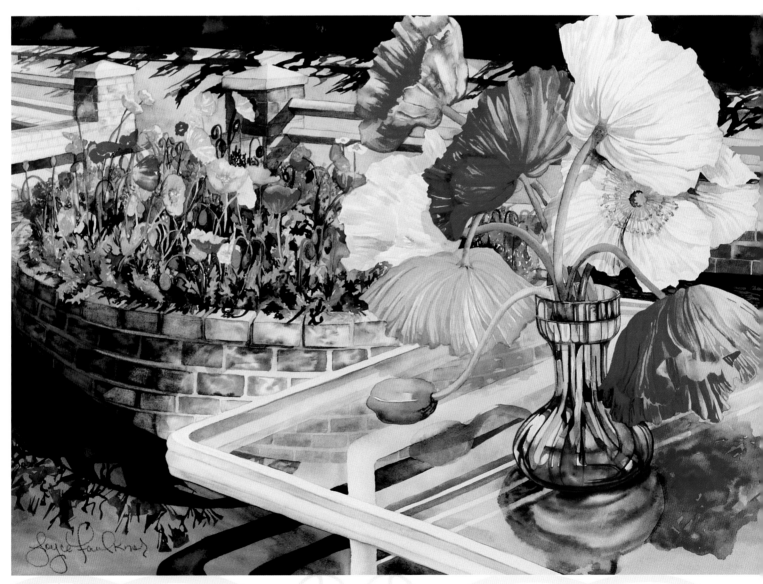

NATURE'S GIFT
22" × 30" (56cm × 76cm)
140-lb. (300gsm) cold-pressed paper

Index